IMAGES
of America

LANDER

IMAGES
of America

LANDER

Carol Thiesse, Traci Foutz, and Joe Spriggs

ARCADIA
PUBLISHING

Copyright © 2010 by Carol Thiesse, Traci Foutz, and Joe Spriggs
ISBN 978-0-7385-8150-7

Published by Arcadia Publishing
Charleston, South Carolina

Printed in the United States of America

Library of Congress Control Number: 2010928313

For all general information, please contact Arcadia Publishing:
Telephone 843-853-2070
Fax 843-853-0044
E-mail sales@arcadiapublishing.com
For customer service and orders:
Toll-Free 1-888-313-2665

Visit us on the Internet at www.arcadiapublishing.com

To all the past pioneers who took the leap of faith for a better life

CONTENTS

ACKNOWLEDGMENTS

We would like to thank Gail Loper for her daily support. Many thanks are due to the past pioneers who had the foresight to take photographs of life in the Lander Valley and to preserve them for future generations. Thanks to the many donors who, in years past, have shared their family history and possessions and have provided all of us great insight into the hardships and joys their forefathers endured to make Lander what it is today.

We also want to thank Loren Jost for permission to use two photographs from the Riverton Museum collection. Thank you to the Fremont County Museums board members Tom Duncan, Eileen Urbigkeit, Butch Tonkin, and Susie Chandler who have provided us continued support in all we do. Sabrina Heise, editor, has been one of our biggest cheerleaders. She has given us much courage and encouragement along the way.

Our most heartfelt thanks go out to our spouses (Mark Thiesse, Charlie Foutz, and Janet Spriggs) for their endurance when the three of us become involved in a project. They have let us walk, talk, and breathe this project and have shared each little victory along the way.

Unless otherwise noted, all images are owned and appear courtesy of the Fremont County Pioneer Museum.

INTRODUCTION

In the foothills of the Wind River Mountains, on the banks of the Popo Agie River, is where history began for a town called Lander. This area saw the first white trappers in 1811, with the first rendezvous in 1829. Gold was discovered in South Pass in 1842. When the mine fields began to play out, many disenchanted would-be miners headed down to the "warm valley" to settle. With plentiful water and good grazing for horses, sheep, and cattle, along with abundant wildlife for food, many felt the desire to stay and settle 10 years before the town was even platted.

The first recorded exploration of the Lander Valley area began in 1833 when Capt. B. L. E. Bonneville arrived in the Wind River Valley and set foot on the site of what is now Lander. It is certain he spent a summer here and found it an area rich in natural resources. The Crow, Sioux, Cheyenne, and Arapaho tribes had been fighting many years for the possession of the Wind River Valley for its good hunting grounds.

There were two major rendezvous in the area, in 1829 and 1838. It is estimated that over 300 mountain men would be camped in a large, several-mile area. In addition, there would also be many hundreds of Native Americans from each tribe wanting to trade furs for firearms, beads, and other goods. Perhaps the chief legacy left by these trappers-explorers of the fur trade was the basic geographical information necessary for the coming westward migration and a more systematic exploration and exploitation of the West.

At the time of the first settlers into this area, there were no roads, only trails. The old Native American trails extended from the Green River Valley where they connected with the trails of tribes from the West Coast; another trail came up from the south joining the trail at South Pass and down into the Lander Valley where it was a well-known camping place to many nomadic tribes. Coming in from the north and west were the trails of the Big Wind and Big Horns, connected with the Powder River and onto the Yellowstone and Missouri Rivers.

Camp Augur was established June 28, 1868. It was named in honor of General Augur, who commanded the Department of the Platte. Chief Washakie of the Shoshone Indian tribe drew up a treaty, which resulted in the building of this fort to protect the Shoshones and white men alike from the warring Sioux, Cheyenne, and Arapaho tribes. The name of the fort was changed in 1870 to Camp Brown in honor of Captain Brown of the 18th Infantry, who was killed in 1866. Sometime in 1871, Fort Brown was transferred 15 miles northwest and in 1878 renamed in honor of Chief Washakie. Fort Washakie remained a fort until 1909, but the town still bears its name, and parts of the old fort are still around.

Lander received its present name through the influence of Benjamin Frank Lowe. When the post office was established in 1875, Lowe suggested that it be named after one of the military men who surveyed the Overland Trail back in 1857. Gen. Frederick W. Lander had laid out a road that would bypass Salt Lake and thereby permit the immigrants to reach the Pacific Coast, staying away from Native American attacks along the Overland Trail.

The title to the original town site of Lander for 120 acres came from the U.S. government, signed in 1880 by Pres. Rutherford B. Hayes, giving Benjamin Franklin Lowe two 40-acre plots and Peter P. Dickinson one 40-acre plot. This land had previously been requested by the government in the Brunot Treaty of 1872 from Chief Washakie to be relinquished to homesteaders. Some 612,000 acres in all, the area encompasses the land between the Sweetwater River and the North Fork of the Popo Agie.

Benjamin Lowe, a former freighter, owned one of the first farms in the Lander Valley. Lowe encouraged an Italian immigrant that owned mines in the South Pass area, Eugene A. Amoretti Sr., to move to Lander and open a general store by giving him land. By 1875, Peter Dickinson and his wife had established the Cottage Home Hotel and Dickinson Livery in Lander. In 1884, these three pioneers established the Lander Townsite Company. With the land surveyed and laid out, lots were for sale, and the official town of Lander was born. Later, in 1884, when Fremont County was established, Lander became the county seat. All this occurred before Wyoming gained statehood in 1890.

As the new county seat for the new Fremont County, Lander set about building. With the coming of the railroad, it was possible to obtain more supplies, faster. First they built a beautiful, brick courthouse. Then they applied to the Carnegie Foundation for a library and received the monies to build the structure. Eugene Amoretti Sr. donated the land, and Lander had one of the first Carnegie Libraries in the state. Next came the Federal Building, completed in 1912 to house the various federal offices, including the post office. Bigger and better hotels, such as the Fremont and the Noble, were built.

The train and "deluxe" accommodations brought in more visitors each year. People living back east were bombarded daily with the grime of factories and grind of living a life in crowded, unsanitary conditions. The lure of Wyoming with wide-open spaces, clean air, blue skies, and natural wonders was hard to fight. Some visitors used Lander as a stopover on their way to Yellowstone National Park, and other visitors came for all the Wind River Mountains offered by way of camping, hunting, fishing, horseback riding, and exploring. A few dude ranches (Happy Valley and Pine Bar) sprang up in the area. These ranches also operated as outfitters during hunting season.

In the 1920s, as Lander was settling into being a community. Tim McCoy, Hollywood legend and Wyoming resident, contacted Lander pioneer Ed Farlow to provide Native Americans for his film, *Covered Wagon*. Ed and his son Jules had many contacts on the Wind River Indian reservations and were successful at hiring the Native Americans seen in the film. Not only were the extras original Wyoming natives, but much of the filming was done in the Lander Valley area. Ed, Jules, Tim McCoy, and the Native Americans soon headed to London for the movie premiere. Stopping in New York City, the crew set up their teepees in Central Park and took in all the attractions the city had to offer. After a few days in New York, the group then set sail across the "big pond"—the Atlantic Ocean—to London. The Native Americans drew huge crowds dressed in their finery of beaded buckskin clothing, moccasins, and headdresses. The teepee village could be seen from all over London.

And so, as the natives of Lander went out into the world, the world came to Lander. Visitors that included explorers, alpinists, and scientists began their travel to Lander—using it as a jumping-off point into the Wind River Mountains and places beyond. They come for the same reason the original settlers came—beautiful scenery, abundant wildlife, and rich resources.

One

EXPLORATION

Lander, located on old Native American trails that connected this area with the rest of the country, had long been the summer grounds for many early nomadic tribes. With abundant wildlife for hunting and plentiful water, many tribes were well acquainted with the Lander Valley area and were trying to establish control of it.

As early as 1811, there is evidence that trappers and mountain men had been in the area. Bound for the West Coast, Wilson Price Hunt and his party crossed Union Pass in the northwest area of what is now Fremont County by following an old Native American trail. In 1812, Robert Stuart led a return expedition from Astoria on the West Coast and discovered South Pass.

Two major rendezvous were held within the Lander Valley—1829 and 1838—near present-day Lander on the Little Popo Agie River. A rendezvous would be spread over a large area, as each trapping party and each tribe would have their own campsites. In order to provide forage for stock, camps were moved several times. Rendezvous experts estimate there were as many as 300 mountain men and as many Native Americans. Perhaps the chief legacy left by these trappers-explorers of the fur trade was the basic geographical information used during westward migration.

The year 1855 brought exploration and exploitation when experienced miners returning from the California gold fields found small deposits of gold along the Sweetwater River. It was not until June 1867 that miners formed the Shoshonie Mining District, though, after the discovery of the Carissa Lode by H. S. Reedall on June 8. News spread rapidly, and there were an estimated 700 to 1,000 men in the region by 1868, but just as rapidly they were gone. By the early 1870s, most of the mines were abandoned.

The 1862 Homestead Act gave discouraged miners, pioneers, freighters, and others an opportunity to start a new life. The act provided settlers with 160 acres of public land. In exchange, homesteaders were required to complete five years of continuous residence before receiving ownership of the land.

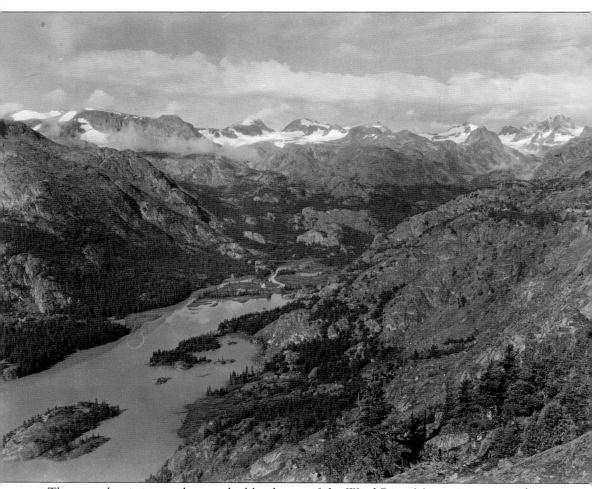

The rugged, pristine, and untouched landscape of the Wind River Mountains was a welcome sight to the white settlers. With abundant game, copious amounts of fresh, clean water, and lush soil, many pioneers made the Lander Valley their home.

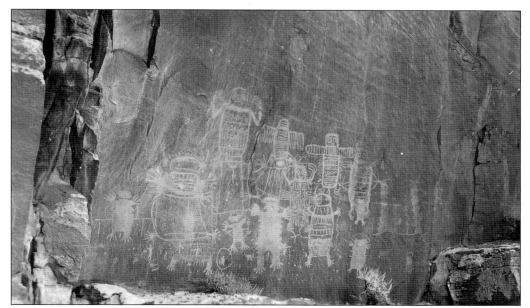

The Native American people were the original inhabitants of the Wyoming Territory and the Wind River mountain area. Petroglyphs like these are just one of many ancient findings that give a glimpse into the lives that once graced this abundant valley.

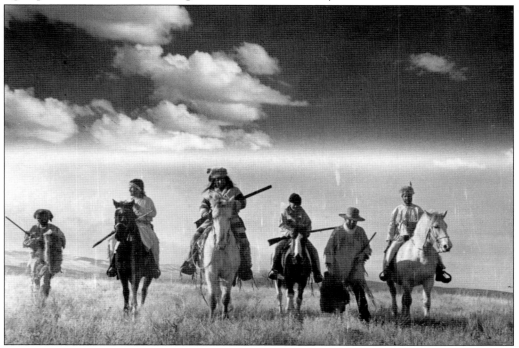

The mountain men trapped in the Wind River Mountains and traded with William Sublette of the American Fur Company. Sublette collected 45 packs of beaver pelts and sent them to St. Louis with Robert Campbell during the 1829 Little Popo Agie Rendezvous. The following year, 1830, also saw a rendezvous on the Little Popo Agie.

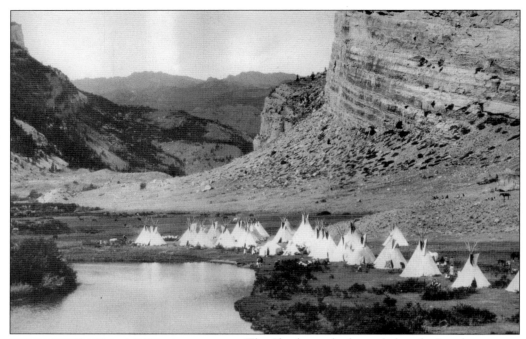

The Shoshones had traveled to the Lander Valley area for their summer camps for many, many years, following the old nomadic trails. Camps like this one provided water for people and stock, good grazing, and a base for hunting.

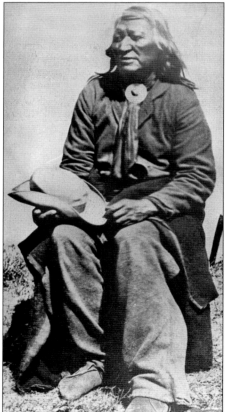

Chief Washakie of the Eastern Shoshones was a great warrior of his tribe, protecting his people from other tribes. His leadership brought his tribe land, which was chosen by him, as well as the honor of having a military fort named for him. Chief Washakie was the key element in the peaceful and rapid settlement of this valley.

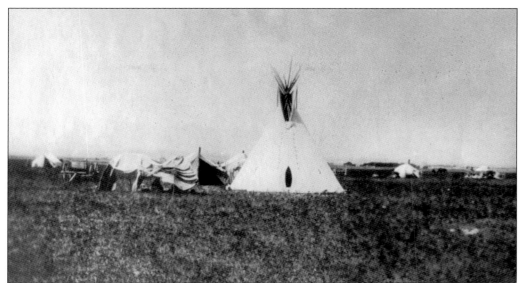

The nomadic peoples of the plains had invented portable housing by using lightweight materials that were easily obtained; they were known as teepees. The teepees were cool in the summer and easily heated in the winter.

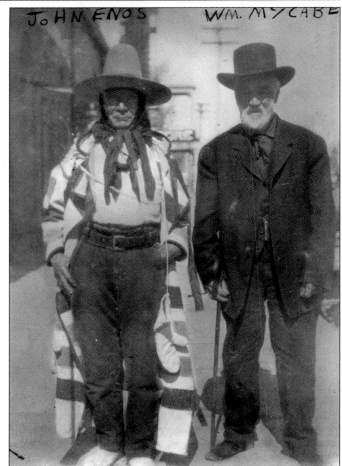

JOHN ENOS WM. MYCABE

John Enos, at 102 years old, and his friend William McCabe, at 87 years old, had both served the cavalry. The scouts were useful to the cavalry for their impressive tracking abilities and their knowledge of the trails and surroundings. Chief Washakie's role as a scout and chief of a band of warriors for the cavalry expedited the building of the forts and the protection of early emigrants, prospectors, and settlers in a vast and hostile territory.

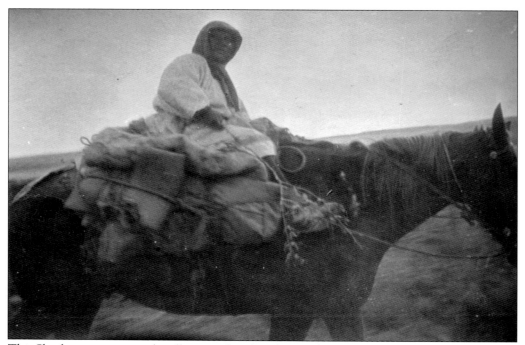

This Shoshone woman, with willow switch in hand, is on the move. She has tied hides and other belongings to the horse and then balances the load by riding on top. She seems quite comfortable without having a saddle.

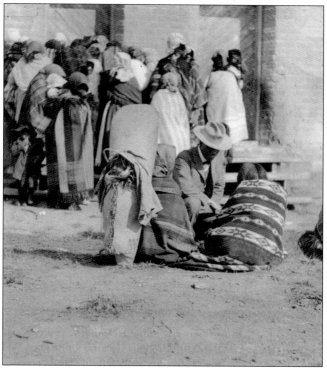

The agency at Fort Washakie became the center of activity as the nomadic lifestyle changed to one of a permanent community. The papoose seems to be enjoying the activities. Here agent Henry Wadsworth meets with the women of the tribe.

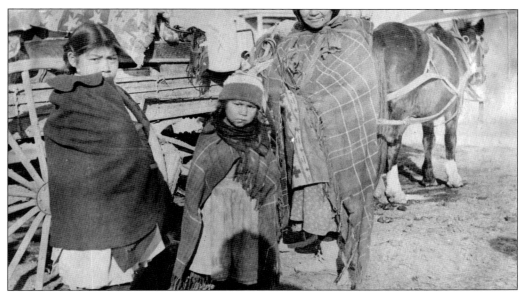

Modern travel with a team and wagon meant less effort and the ability to take more people and gear. Healthy children attest to an easier lifestyle of Fort Washakie.

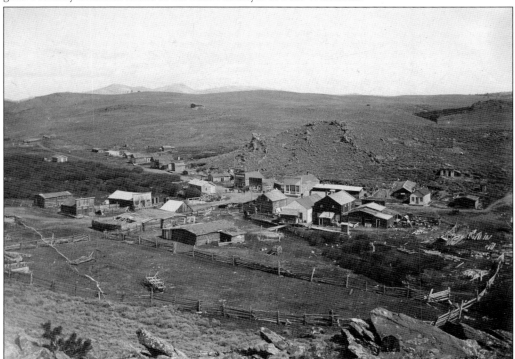

At the southern end of the Lander Valley, South Pass City was one of the largest original settlements in the Wyoming Territory, with a population of over 4,000 people at its peak. Within a few short years, this booming gold community diminished rapidly and became a ghost town. Some of the miners moved on to the gold fields in California in order to continue their quest for gold, but some other miners, as well as the entrepreneurs, moved to the lush, agriculture rich Lander Valley.

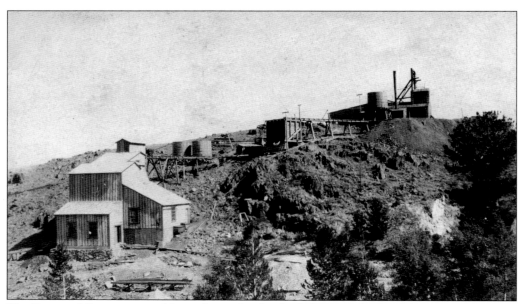

The Duncan Mine was one of the earlier and richer load claims in the South Pass area. The mine produced about 3,790 ounces of gold. Jim Duncan, in the spring of 1868, was the original locator.

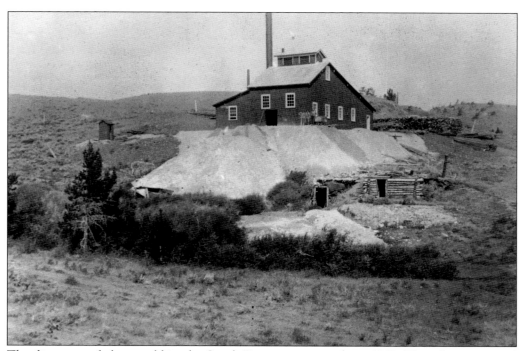

The discovery of placer gold in the South Pass area was made in 1842. Though mining and prospecting continued, it was not until H. S. Reedall discovered the Carissa Lode in 1867 that the rush began. Here at the Rose Mine, owned by W. J. Bryan, mining was going full steam ahead. By 1872, the entire area was nearly deserted.

Placer mining was just one of the ways that prospectors searched for gold and was one of the more common methods used. Placer mining, done in the rivers and streams, is also known as "panning" for gold. Closed shaft, or hard rock, mining was also a common type of mining; the Carissa Mine is a closed shaft lode mine and produced tremendous amounts of gold.

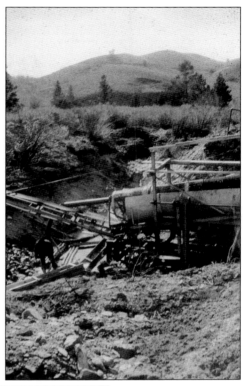

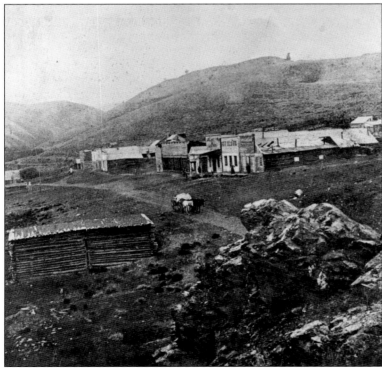

Atlantic City had enough people in the spring of 1869 to form a community of several hundred. Most of the mines—such as Lewiston and Miners Delight—were within 4 miles. The water on this side of South Pass, the Continental Divide, drains to the Atlantic Ocean, hence the name Atlantic City.

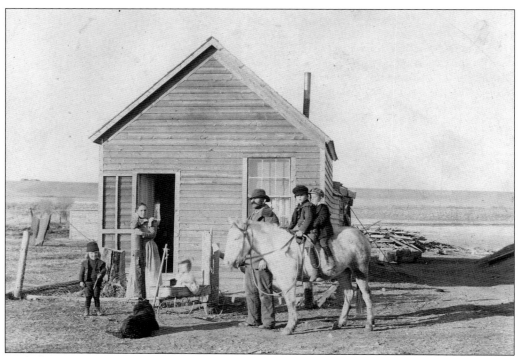

With the signing of the Homestead Act in 1862, settlers like the Gustins left the mines of Lewiston and came to the Lander Valley to raise livestock, gardens, and a family. The meager beginnings soon turned into a comfortable lifestyle.

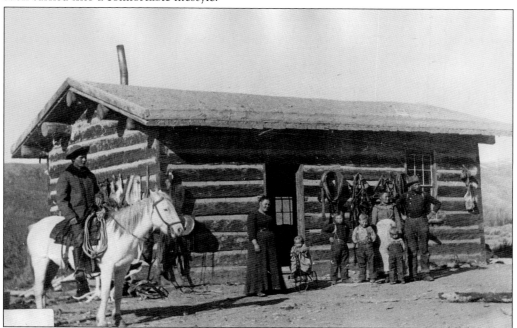

The Boedeckers also took advantage of the 160-acre homesteads and built this fine log cabin on Poney Creek. It was a great base camp for the hunting, fishing, and trapping lifestyle.

Two

LOCALITY

In 1869, the settlement, where the town of Lander now sits, saw many people pass through it for a multitude of reasons. The original name of this settlement was Camp Auger, named so after Gen. C. C. Auger. Brigadier general of the 12th Infantry of the U.S. Army, Auger commanded the Department of the Platte, which led him through the area. The Department of the Platte ran along the Overland Trail and was used as a guideline for where the transcontinental railroad would eventually run.

A year later, in 1870, Camp Brown was established in the place of Camp Auger. Camp Brown was named after Capt. Frederick H. Brown, who was assigned to the Wyoming Territory with the 18th Infantry unit to build forts. Brown was killed along with approximately 80 other men at the Fetterman Massacre in 1866. After the Fetterman and Kidder massacres, the U.S. military abandoned the Bozeman Trail.

In 1871, Camp Brown was moved approximately 15 miles and, in 1878, renamed Fort Washakie, in honor of the Eastern Shoshone chief Washakie; this was the only time in history that a military fort would be named after a Native American chief. The fort was moved for the purpose of protecting the Eastern Shoshone tribe from their enemies: the Sioux and Crow tribes. In a revision of the Brunot Act of 1872, the year 1874 saw negotiations for the southern portion of the Shoshone Reservation to be made available to the white settlers, in exchange for $20,000 worth of cattle and $5,000 to be paid to Washakie over a five-year period. Finalized in December 1874, this land cession agreement was called the Brunot Cession.

Eventually, the original town site was named Lander, after Col. Frederick W. Lander, at the urging of Benjamin Franklin Lowe. Lander was a civil engineer and surveyor; the U.S. government employed him on transcontinental surveys to select a route for a Pacific railroad. The pioneers who had made the area their home remained, and the town of Lander was established in 1884.

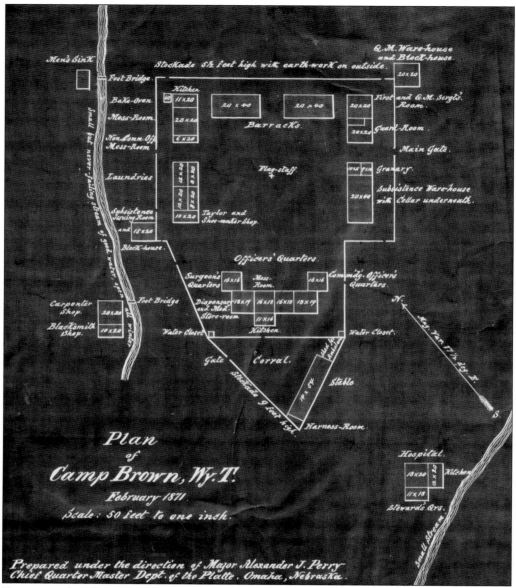

Plan
of
Camp Brown, Wy. T.
February 1871
Scale: 50 feet to one inch.

Prepared under the direction of Major Alexander J. Perry
Chief Quarter Master Dept. of the Platte. Omaha, Nebraska.

Two years after the treaty between the Eastern Shoshone tribe and the U.S. government was signed at Fort Bridger (July 3, 1868), Camp Brown was established as a military post to provide protection to the tribe as part of that treaty. The treaty was signed by the chief of the Eastern Shoshone, Chief Washakie, who was very instrumental in working alongside the U.S. government to find a peaceful solution that would benefit his tribe as well as the white settlers.

Historical documentation indicates the Wind River Agency Blockhouse was built in early 1871 under the direction of the new Indian agent, Dr. James Irwin. With sandstone walls, gun portals, and an 8-foot-square rooftop sentinel box accessed by an interior ladder, the blockhouse provided effective protection against Native American attacks, which were a regular occurrence during this time. A well was sunk under the floor to provide water, while supplies to feed the entire agency for one month were lined along the walls.

Fort Washakie became a Native American agency in 1871 and continued as a military post. With the implementation of the agency, life on the reservation changed for the Native American, bringing with it "civilized" schooling and trade, as well as annuities and rations from the government. The mission of the agency was to oversee all the commerce and activity for the tribe, including the bookkeeping, shipping, and other infrastructure.

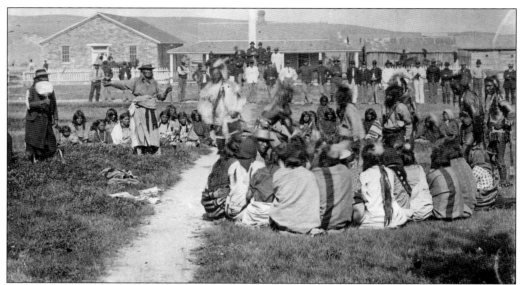

The government buildings of Fort Washakie were many and very substantially built, as construction was from native stone and brick masonry. The tribal members saw and embraced the fact that it was for their protection and well-being. The Native American community would gather at the fort, and on this occasion they are performing a war dance under the guidance of Chief Washakie, who is pointing out instructions to the drummers, singers, and dancers.

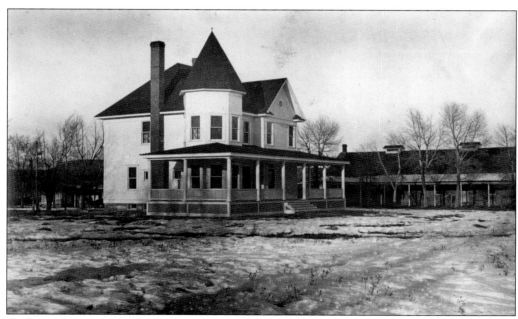

Dr. James Irwin was the first Indian agent at the Shoshone Agency and was the first occupant of the Victorian home built for the appointed Indian agent. The fort compound was the immediate area around the government buildings, and it included many residences and service buildings. It became the center of Native American activity.

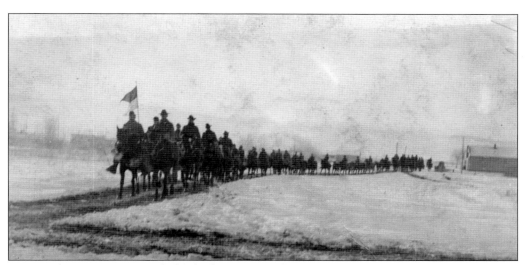

In 1893, the post at Fort Washakie had a garrison of 115 men and was enlarged to accommodate more troops. Winter snow and below-freezing temperatures made a hard job even tougher. These mounted cavalrymen, leaving Fort Washakie, dealt with the conditions as part of the job.

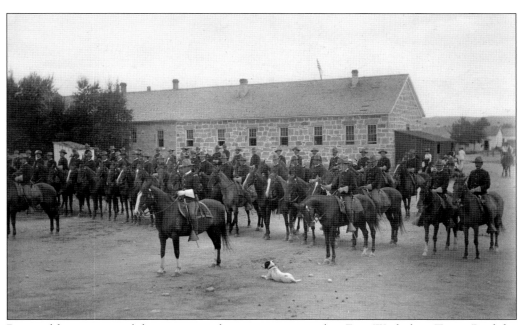

Pictured here is one of the many cavalry troops stationed at Fort Washakie. Troop B of the 8th Cavalry is lined up for inspection in front of the stone cavalry barn in 1898.

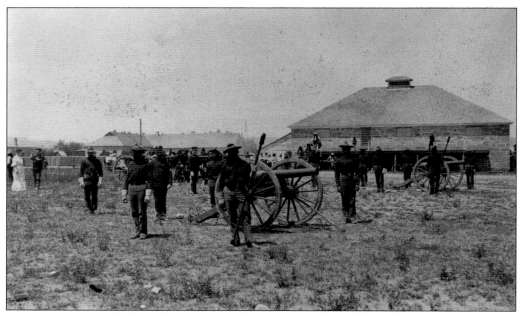

The cavalry utilized light artillery cannons that were moved by mules and horses. Practice with the canons was sure to draw a crowd. (Riverton Museum Archives.)

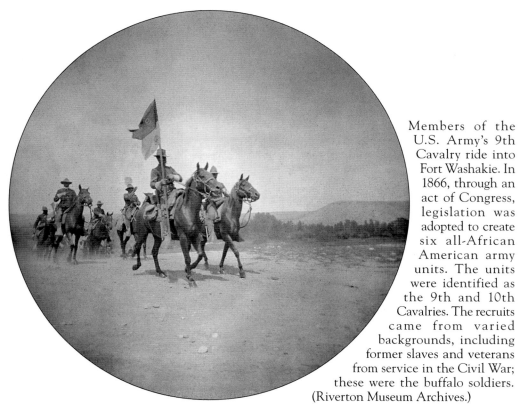

Members of the U.S. Army's 9th Cavalry ride into Fort Washakie. In 1866, through an act of Congress, legislation was adopted to create six all-African American army units. The units were identified as the 9th and 10th Cavalries. The recruits came from varied backgrounds, including former slaves and veterans from service in the Civil War; these were the buffalo soldiers. (Riverton Museum Archives.)

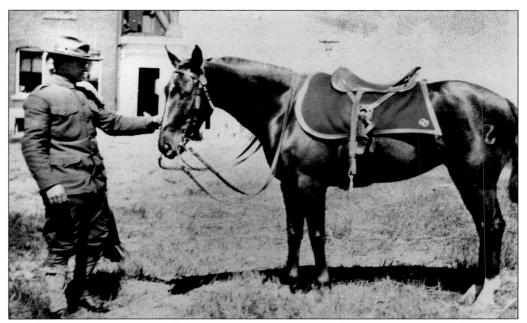

Cavalry blacksmith George Sitkei, in his uniform on the parade grounds at Fort Washakie with his well-groomed mount, shows the pride and care given to the cavalry horses.

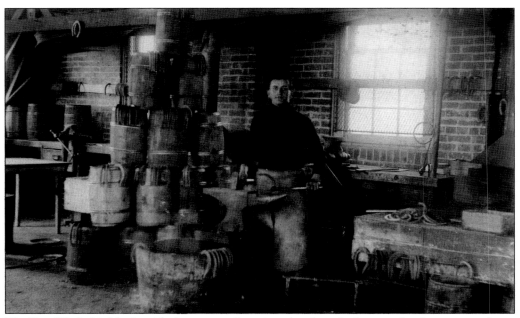

The Fort Washakie blacksmith shop was well equipped and stocked to care for the mounts of over 100 troops, the many wagons, and other rolling stock. The shop had workstations for more than one blacksmith. This young blacksmith is working on a horseshoe in front of a forge.

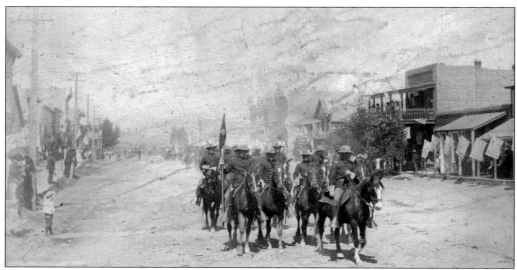

Capt. K. P. Sayer led the Troop B 8th Cavalry 15 miles to Lander from Fort Washakie to be in the Fourth of July parade festivities in 1898 on Lander's Main Street.

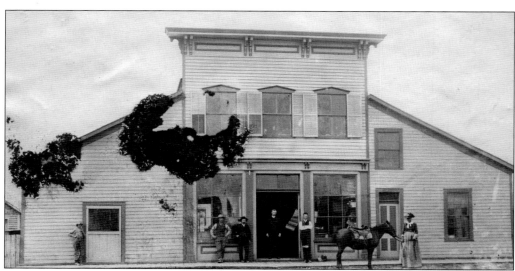

James K. Moore was the first merchant permitted to run a trading post on the Shoshone Indian Reservation. Supplies were needed for the cavalry and the Native American population of the area, so the traders' business was very good. Contracts with the fort to supply beef and other commodities were made with J. K. Moore. Moore had a store on Main Street in Lander from about 1875 to 1890 and at Milford and Fort Washakie.

The Moore store at Fort Washakie was a very complete mercantile with a post office, hotel, stage stop, and livery for the local residence and travelers. J. K. Moore's trading with the locals brought about his use of the Moore's trade tokens, which were called "yellow money" by the Native Americans.

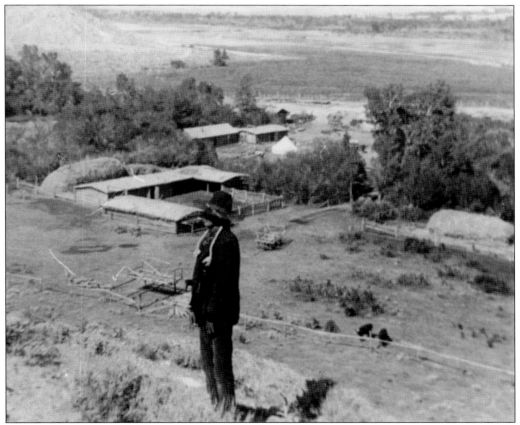

The trading post business of J. K. Moore expanded to include a cattle ranch to supply beef for the stores and the cavalry. The old JK Ranch on the Wind River was set up to raise and handle a large herd.

Col. Jay L. Torrey and his brother, Capt. Robert A. Torrey, were partners with J. K. Moore and bought the EM Bar Ranch, expanding cattle and ranching in the Wind River area. Colonel Torrey was to muster enlistments from the Wind River and Big Horn Basin area for the 2nd U.S. Volunteer Cavalry, which became known as Torrey's Rough Riders.

WHILE WE GO RIDING WITH TORREY.

Written by Mr. C. P. P. Story, of the Sheridan Post, and dedicated to Colonel Torrey and his fellow patriots of the Second U. S. Volunteer Cavalry (Torrey's Rough Riders).

Air, Marching Through Georgia.

Now up and cinch your saddle, boys,
 And buckle on your gun,
And when you touch the stirrups
 Let your horse be on the run;
For they tell us down in Cuba
 That we boys will have some fun,
 While we go riding with Torrey.

CHORUS.

Hurrah! Hurrah! The chorus we will swell,
Hurrah! Hurrah! It's the cowboy's turn to yell;
 There's a gun for every puncher,
And we know our leader well,
 While we go riding with Torrey.

Uncle Sam will make a round-up
 On the range across the bay —
He wants a thousand "reps" to go
 With Torrey, so they say,
To handle the U. S. irons
 In a systematic way,
 While we go riding with Torrey.

Now, when it comes to riding, boys,
 Our bronchos are the best;
They'll find the Western cowboys
 Are equal to the test;
It's cartridges and guns we want,
 And we will do the rest,
 While we go riding with Torrey.

So, boys, we'll make a round-up
 Of the Dons who fired the Maine;
We'll burn the U. S. brand so deep
 'Twill not be held by Spain;
And on the Western soil we'll meet
 At the home ranch once again,
 While we go riding with Torrey.

C. P. P. Story of Sheridan wrote the song for Torrey's Rough Riders, "While We Go Riding with Torrey," a recruiting effort for the Spanish-American War.

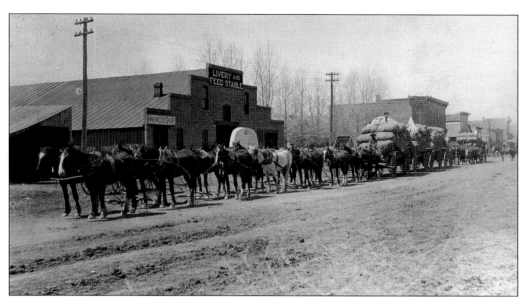

Great freight outfits pulled their heavy burdens from Rawlins to Lander and over the hills to Fort Washakie for years. It was the main road of the Lander Valley and carried immense tonnages of freight and thousands of people. This photograph in front of Vaughn's Livery and Feed Stable on Main Street around 1886 shows a 14-hitch team made up of both mules and horses. The main road in Lander, which became Main Street, was built wide enough to allow a 20-hitch team and wagon to turn around.

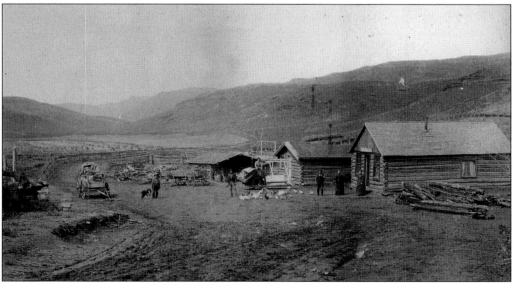

The William Tweed homestead developed into, as some would say, a plantation. The location, Red Canyon, was of a lower elevation than the mines of South Pass but on the road to Lander and Fort Washakie. Produce was raised for both the mines and for the cavalry. William "Boss" Tweed catered to the travelers that stopped for a change of horses on the stage, or overnight accommodations. Boss Tweed was one of the first to bring domestic sheep into the area.

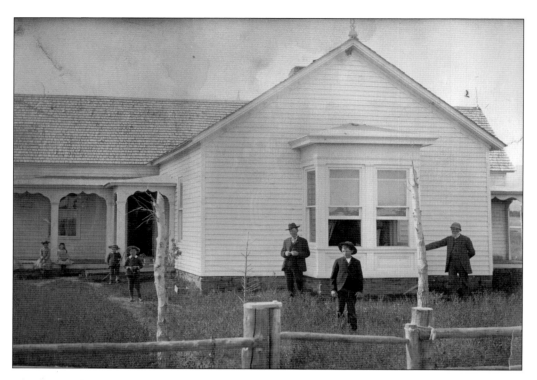

The first trading post, built in 1866 by Noyes Baldwin, was located on the river near the present town of Hudson at the site of the Bonneville Cabins. This site was abandoned when hostile Native Americans forced him to move his store back to South Pass. In 1868, Noyes built another trading post just north of Lander on a small creek now called Baldwin Creek, but the Native Americans again forced the family and business back to South Pass. Maj. Noyes Baldwin eventually built his home in Lander in 1879 for his family of 11 children. His son George L. Baldwin, the boy in the foreground, was the first white child born in the Lander Valley on May 4, 1869. The Baldwin's store, built in 1883 of stone and masonry construction, became the center of Lander and operated until the mid-1990s as the M. N. Baldwin Company.

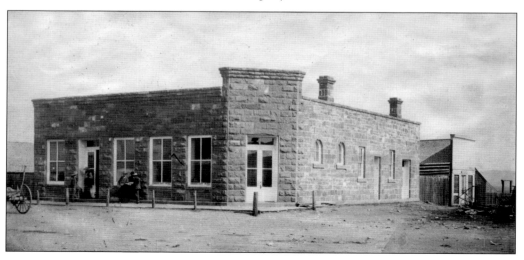

Three

SETTLERS

The first settlers in the Lander Valley area built homes near the site of Camp Brown, the original Indian agency. Newton H. Brown, professional surveyor, established the survey corners throughout Fremont County when it still included parts of Sublette County, Hot Springs County, and the Native American reservation lines.

After serving in the Civil War, Ervin Franklin Cheney heard of the gold rush in the South Pass area and built a blacksmith shop there. By 1876, he had established a shop in Lander. He sold out in 1900 when the Cheney family purchased a ranch on the North Fork of the Popo Agie River. Cheney spent two terms as the Fremont County treasurer and was registrar of the U.S. Land Office for eight years.

The Desert Land Act in 1877 opened new lands for production through irrigation. The act offered 640 acres at 25¢ per acre and the promise to irrigate within three years. The Lander area has an abundance of water for irrigation.

The ability to grow major crops, such as hard spring wheat, barley, oats, alfalfa, and corn, made Lander an ideal area for farming and ranching—sheep and cattle were raised in great numbers. The large farms of Guinard and Tweed in Red Canyon began by supplying produce to the miners in the South Pass area. Ed Young started his apple orchards in the Little Popo Agie River area. The State Experimental Farm, which adapted crops for the higher altitudes and shorter growing seasons of Wyoming, was in Sinks Canyon. The Lander area produces some of the finest honey in the country. Lander farmers have always been top grass and alfalfa hay producers, and they raised hay for winter feeding. Fruits and vegetables were also raised in great quantities.

In 1878, the U.S. government placed the Arapaho tribe on the Shoshone Indian Reservation. What was originally intended to be a temporary measure became permanent. The Arapaho were destitute when they reached the reservation, subdued by starvation and the military during the Plains Indian Wars. Because of the long-standing animosity between the Shoshone and Arapaho, the tribes remained in separate communities.

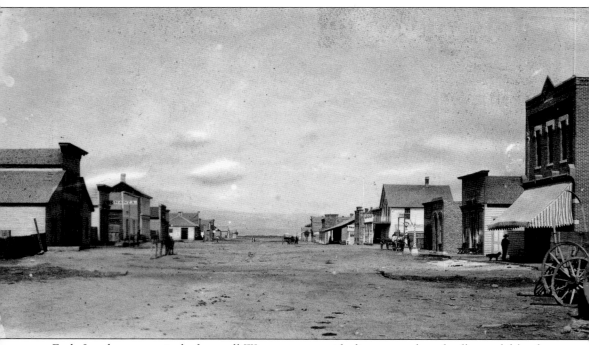

Early Lander was typical of a small Western town with dirt streets, boardwalks, and false front buildings. Foresight from the settlers quickly brought schools, religion, prosperous businesses, and medicine to the area.

Newton H. Brown (1853–1942) and his wife, Linda Sterling Brown, came to Lander in 1883 as schoolteachers. He taught in Lander, and Linda taught at Borner Gardens. In 1884, he started his surveying business. With a buckboard, theodolite, and camp outfit, Brown was responsible for surveying most of Fremont County.

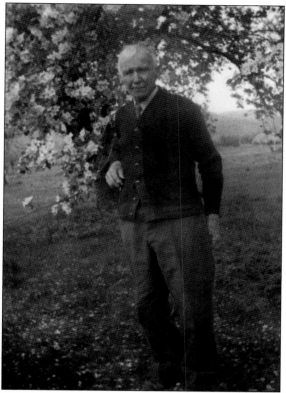

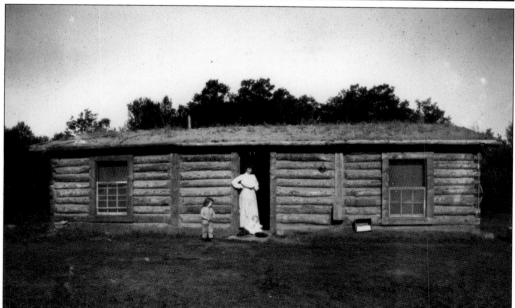

With the opening of the public lands, homesteads were springing up all over the Lander Valley area. This was a nice log cabin with a sod roof. Windows were covered with an oilpaper, making it dark inside especially on cold, snowy days but better insulation for those harsh Wyoming winters.

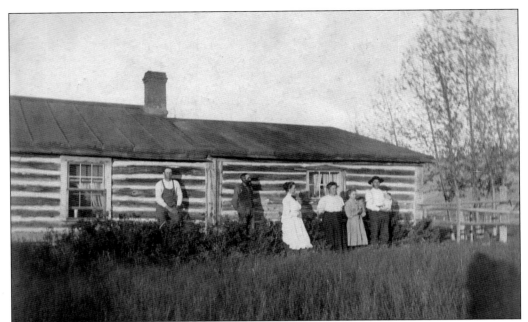

Among the earliest settlers in the Lander area were the Hornecker brothers from Missouri. Ernest and Mart arrived in Cheyenne in 1869, and then moved to Miner's Delight in answer to gold fever. Albert arrived in 1877, while George finally made it west in 1883. Both Ernest and Mart homesteaded in the Borner Garden area. Pictured is Ernest's modest log homestead cabin.

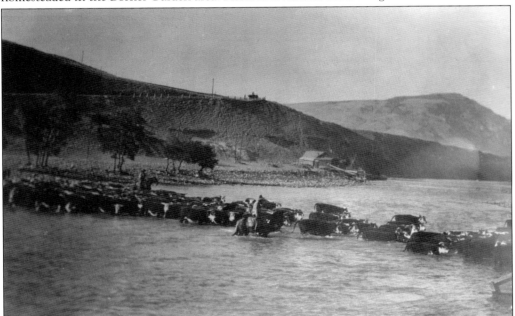

Many of the settlers went into the livestock business. Cattle drives occurred during the spring and fall when ranchers were moving their herds to different pastures. There is a lead and two men riding flank (on each side of the herd), while always one in the back or drag. Crossing water was especially treacherous in the spring with winter snow melt raising the water to dangerous levels.

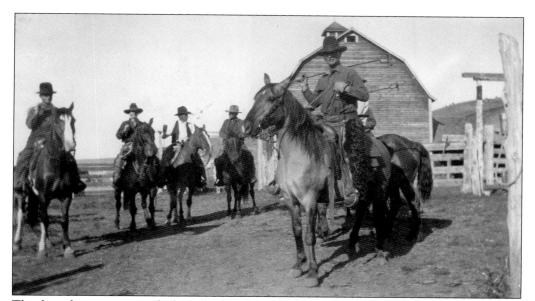

This branding crew is ready for a hard day's work. Once the cattle are rounded up, they are contained in pens until the next day when the branding crew is ready. Brands were the mark of ownership on these cattle that at least six months of the year roamed free on the open range.

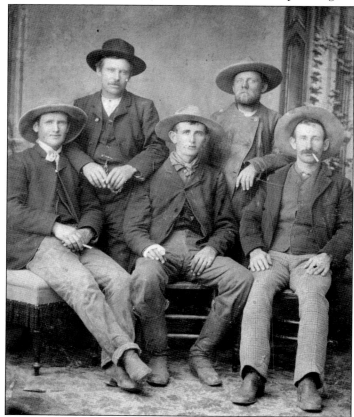

To be successful in ranching, it took young men willing to work long hours in the saddle in all types of weather to take care of the cattle. Pictured are cowboys from the Lee Outfit, as follows: Will Lanigan, Ed Lanigan, Tom Tway, Jimmie Burrows, and Dave Pickard.

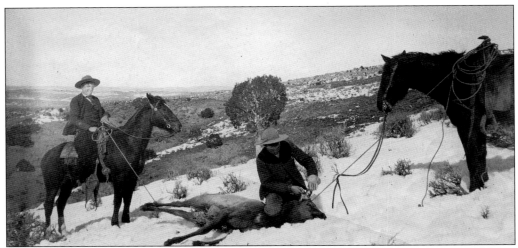

All the time alone gave cowboys the opportunity to think up lots of ideas. Cowboys have always been known for their fun-loving ways and practical jokes, as shown here roping an elk. Bad enough they roped it, but then they got down to ear-notch it, just like with cattle.

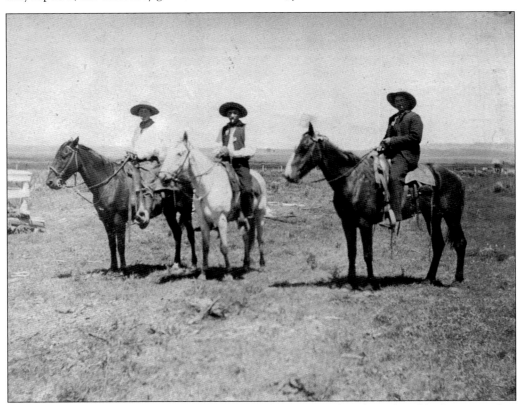

Some cowboys would stay at one ranch as long as there was work to do. Others liked to roam a bit, not be tied down, but instead have the opportunity to see the country. Shown here are Charlie Dollard, Charlie Van Patten, and an unidentified friend, who worked from the Sweetwater country up through the Lander Valley area and into Dubois.

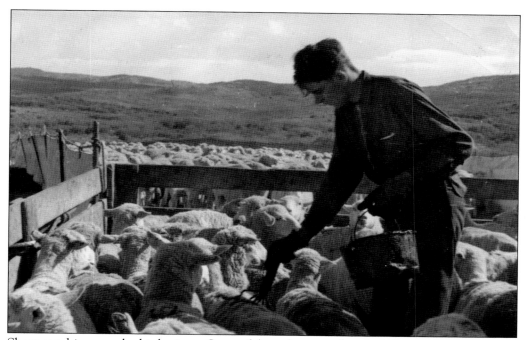

Sheep ranching was also big business. Some of these sheep ranchers had 50,000-plus sheep. Since sheep was also kept on the open range, they needed to be branded. However, because the wool was a source of income, sheep were branded with paint.

Just like cattle ranching, sheep ranchers depended on men that would live in isolation for months at a time with just a couple dogs for company. Instead of bunkhouses, sheepmen used sheep wagons, or sheep camps. Everything needed was contained in these wagons. A camp tender would come out every 10–12 days and resupply the sheepherder.

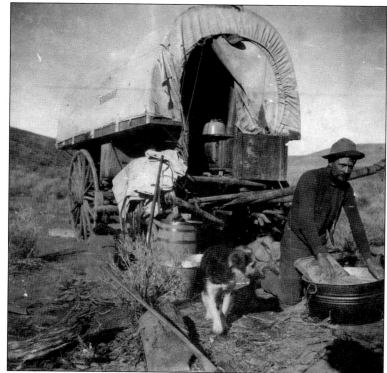

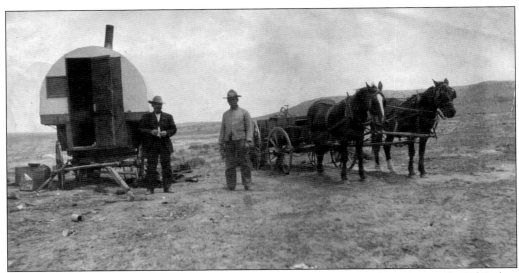

Early pioneers, the Farlows, had interests in many areas, including ranching. Pictured is Ed Farlow resupplying his son Stub at their sheep camp on Muskrat Creek.

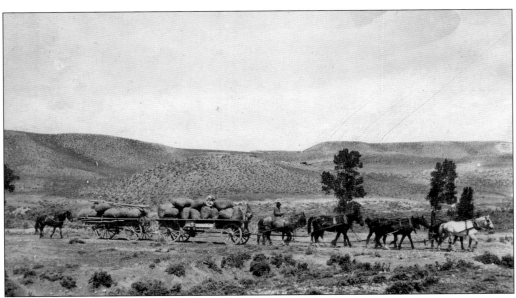

Sheep were raised for their wool. In the early spring, all the sheep were rounded-up at centrally located shearing pens. A good shearer could shear 50 sheep a day. It took 500 pounds to fill each sack. Once done, the sacks were hauled by freight team to Rawlins to be put on the railroad and processed back east.

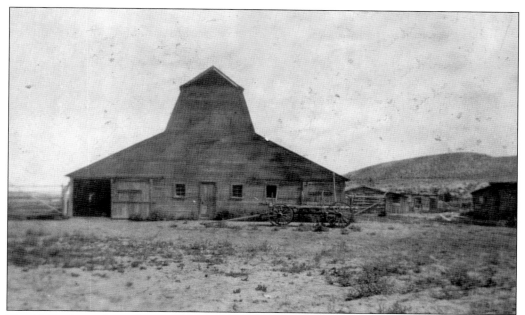

The Hailey barn shown here was typical of barns on the various homesteads and ranches. Milk cows, horses, goats, chickens, and geese all needed protection from the weather. Hailey was also a stage stop, so this barn was used for the stage teams.

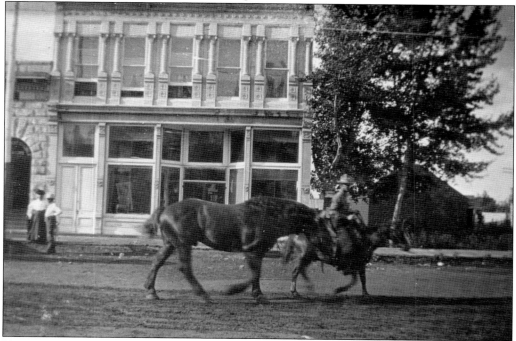

Horses were another commodity for ranches in the Lander area. Ranchers would go to Europe and buy the best bloodlines they could to start a breeding program of draft horses and ranch horses. Clarence Knifong is moving his Percheron stallion down Main Street in front of the Noble Lane building.

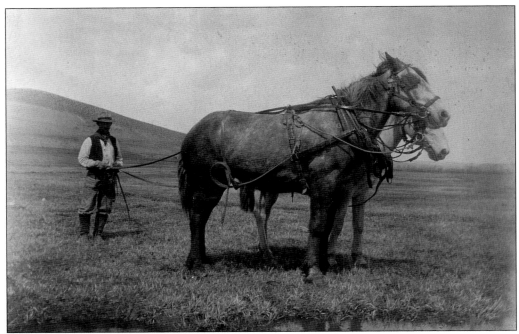

Shown here is the Percheron team used by John Carr on his ranch and farm. These draft horses were a vital part of any farming operation as they did all the heavy work. Standing 18 hands tall and weighing in at 3,000 pounds, they put in a full day's work.

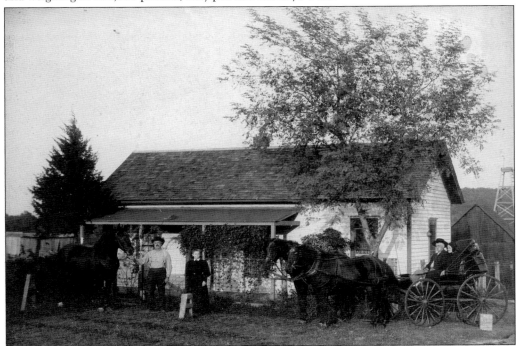

Brothers Orson and Alva Grimmet were also very proud of their horses' bloodlines. Shown at left is the beautiful draft stallion, while at right are a matched pair of carriage horses.

Clarence Knifong is pictured bringing his horses out of the barn. Horses were called on to do all the farming and ranch work, as well as being used for transportation. Great care was taken of all the horses, as evidenced in the pride shown by their owners. Like cowboys, the men that ran these teams were with these horses all day, every day, and a lasting trust and partnership developed.

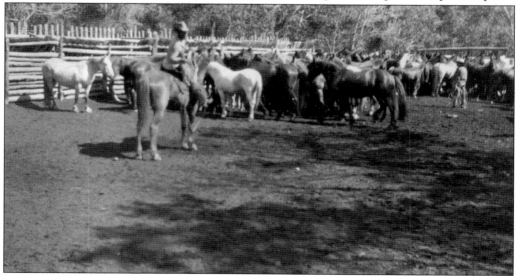

If a ranch was running a lot of cattle, more horses were needed. Here is a nice cavvy (herd) of horses ready for the days use. Each cowboy had five or six horses that were "his." That day's work determined which of his string would be used. The cowboy would call out the horse's name and the boss would throw a loop and catch him up.

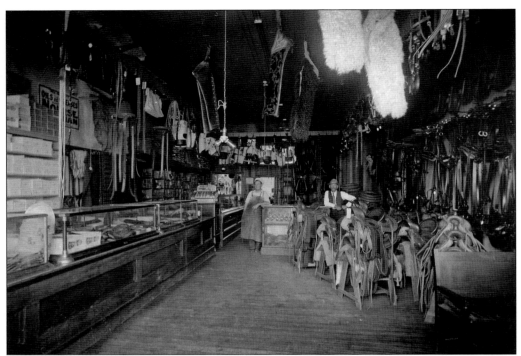

Where there is ranch work and farming being done, there is a need for a saddle shop and leather shop. Hamilton Wort opened one of the first of these shops in the area. As shown in the photograph, the shop contained many saddles, chaps, harnesses, boots, belts, and most anything else a cowboy would need.

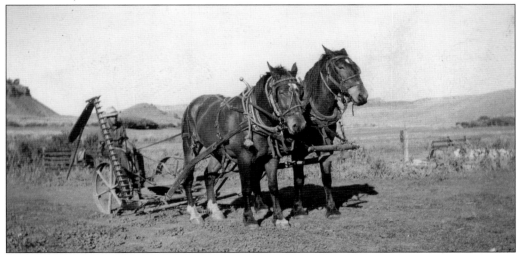

The invention of the horse-drawn mowing machine was one of the most advantageous pieces of equipment a farmer or rancher could own. It allowed them to cut and stockpile winter feed for horses, cattle, and sheep. The more feed that could be put up for winter, the more stock that could be raised, and therefore, the more money that could be made—all from an efficient machine that replaced the hand scythe and hay cradle. John Auer was the proud owner of this machine that served him well for many years on Beaver Creek.

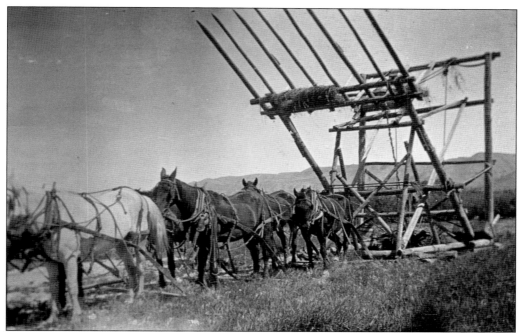

This hay stacker is used with a six-hitch team. The hay was then stacked in giant "bread loaf" looking stacks enclosed with fencing. Haying is always at the hottest point of the summer, but the end product was feed for the coming winter. Ranches owned by Joseph Himmelsbach and John Reid up Willow Creek would produce over 200 tons of hay annually.

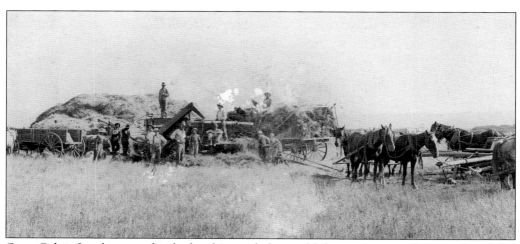

Once Calvin Leseberg was finished on his ranch, he would then go from ranch to ranch with his thrashing machine until all the thrashing was finished for the year. Fourteen horses were used to power the thrashing machine. Cal Leseberg, Del Goodrich, and Orin Avery are the only men identified in this 1900 photograph.

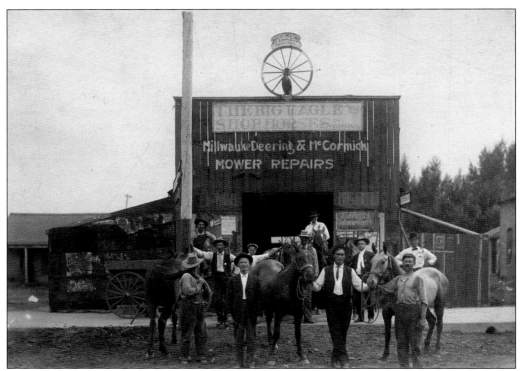

If there is equipment, there is need for a repair shop. The Big Eagle could handle all the repairs for Milwaukee Deering and McCormick equipment. In addition, they sold leather goods for horse teams, were a livery, and advertised horse "shooing." Shown here, among others, are Lee Welch on horseback in the doorway, Eugene Jones, and Charlie Sheehan.

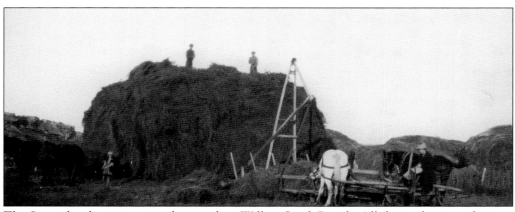

The States family is putting up hay on their Willow Creek Ranch. All the work on ranches was a family affair. Here Mignon is driving the stacker with Margaret on the buck rake. Herbert and James are on top of the stack.

Just as ranchers would work at supplying winter feed for their cattle, sheep, and horses, the many farmers in the area worked at supplying people with a variety of food products. There were quite a few hog producers in the area. Everyone, including children of all ages, understood exactly where their food came from and how it was produced.

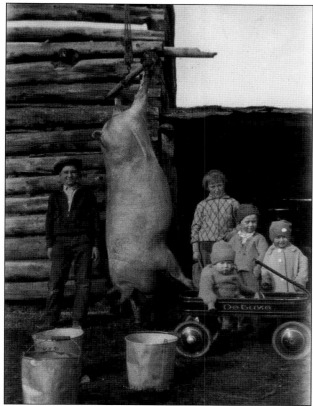

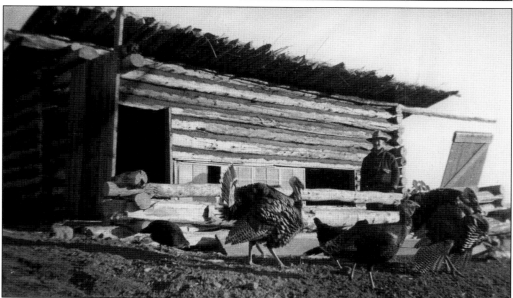

Turkey farming was also quite popular. Since the turkeys could be kept close to the homestead, the women were usually in charge of the feeding along with their regular duties of milking the cow and feeding the chickens.

Esther Cheney is pictured at her father's (Ervin F. Cheney) blacksmith shop. Cheney was a wainwright (wheel maker) and blacksmith that first settled in South Pass (1869). With South Pass being on the main freight road between Rawlins and Fort Washakie, Cheney had plenty of work. After he married Matilda Henry in 1875, they moved to Lander.

Cheney opened his blacksmith shop in 1875 in Lander, one of the first, just west of the Middlefork River. In addition to his shop, Cheney also served on the Territorial Legislative Assembly, as clerk of court; was Fremont County treasurer; and was registrar of the U.S. Land Office. In 1900, he built a ranch house on the North Fork and moved north of town with wife Matilda; daughters Esther, Mabel, and Emma; and son Ervin.

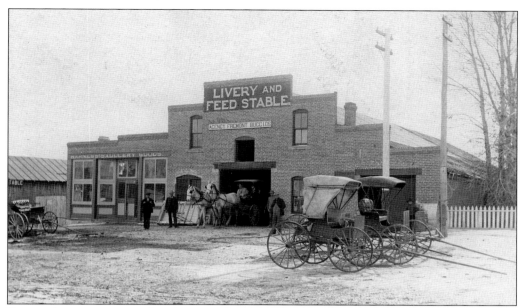

During the pioneer era in Lander, everything that happened depended on horses. Liveries and stables were a necessary business where wagons were sold, made, and repaired; horses shod and stabled; harnesses and saddles made and repaired; and freight loaded and unloaded. P. P. Dickinson had one of the first liveries, but Vaughn's and Oldenburg's also did good business.

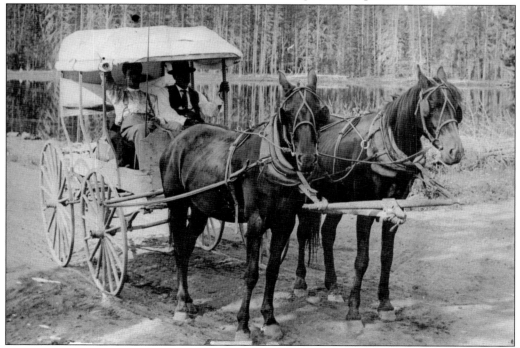

Not everyone owned horses and/or carriages. The liveries would rent outfits (carriages, buggies, teams, and tack) by the hour, day, week, or longer. These men are enjoying an outing in the mountains.

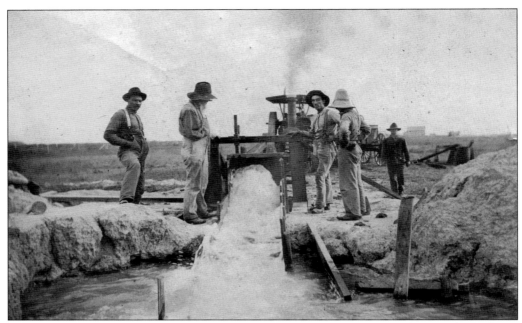

When Congress passed the Desert Land Act in 1877, it allowed individuals to apply for desert land entry to reclaim, irrigate, and cultivate semiarid lands. The first irrigation ditches and canals were either dug by hand or by horsepower with a horse and a slip to trench out the ditch.

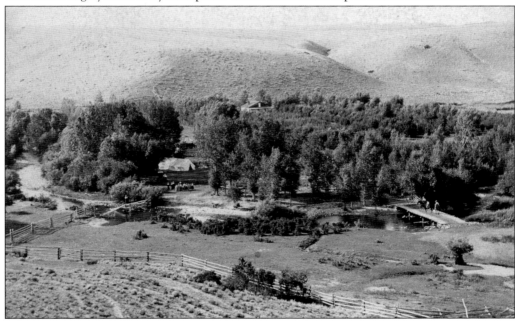

Ed Young's Arbor Lodge at the foot of the Little Popo Agie Canyon provided an ideal location to produce fruit. Ed owned 400 acres and leased another 800 acres to grow the finest apples in the region. Coming to the Lander area around 1872, Young built a 22-foot waterwheel to irrigate his orchards. In 1909, the estimated harvest was 2,000 bushels. Born in England in 1843, Ed Young died in Lander in 1930.

Jacob Meyer and his wife, Carrie, came to the Lander area to farm. In 1891, the State of Wyoming Agriculture Department put out bids for the State Experimental Farm next to the Meyer farm. Jacob applied and became the first superintendent. He died in 1898; Carrie continued to live on the farm with their three daughters—Julia, Nellie, and Minnie.

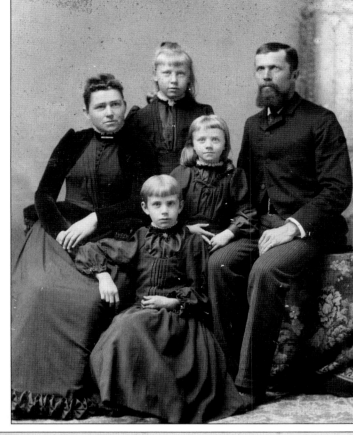

The State Experimental Station under Jacob Meyer produced many fine crops raised specifically for high altitude areas with a very short growing season. In 1897, the state had no more funding, and the Meyers leased the farm.

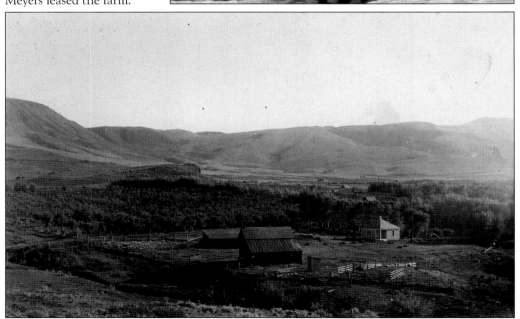

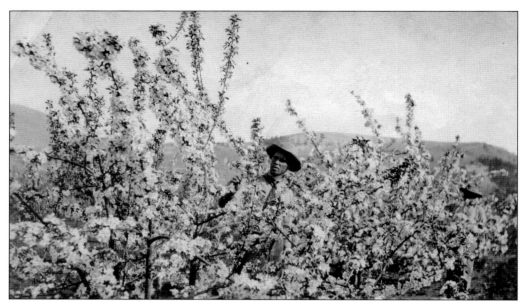

John Steinbrech had been a cowboy in the area, but with his horticulture background, he decided to take up farming. He leased the State Experimental Farm in 1910. Finding more funding, the state asked Steinbrech and his wife, Mary, to stay. A residence was built, with two more rooms added in 1912. The experiments with produce benefited farmers not only in Wyoming, but all across the Rocky Mountain region. John is shown here among the apple blossoms.

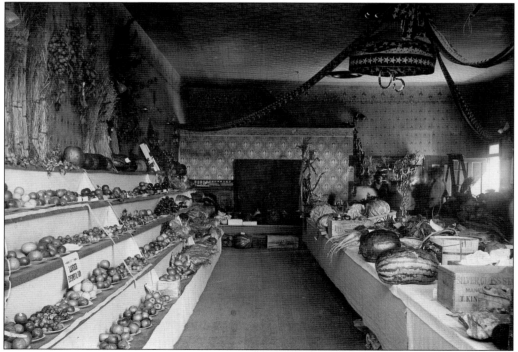

There was always a wide variety of produce at the Fremont County Fair—apples, strawberries, plums, melons, and a huge assortment of vegetables.

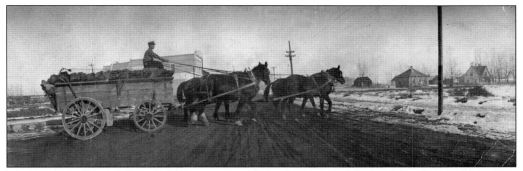

The Lander Valley ranchers and farmers were such good stewards of the land that they could produce enough food for themselves and the cavalry at the fort and have plenty to ship to other towns. Delivery wagons were needed to get the produce from the farms into town and points beyond.

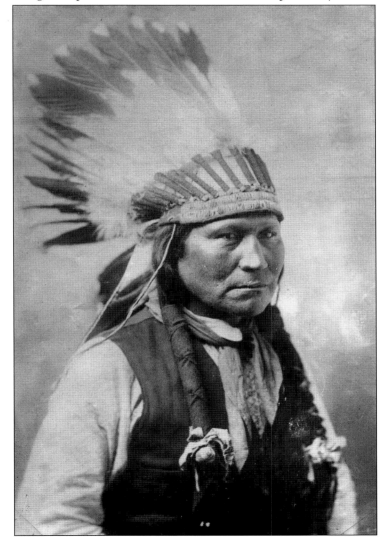

In 1878, the Northern Arapaho tribe was moved onto the southeastern portion of the Shoshone Indian Reservation. Chief Washakie was very vocal in his opposition to having the Shoshone enemies housed in the same area. Chief Black Coal moved his group on the reservation near the forks of the Popo Agie and Wind River, establishing farms and ranches.

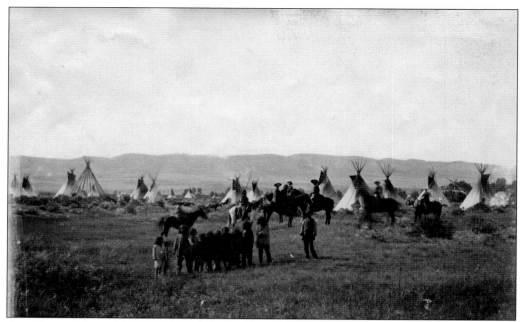

Arapaho camp on the reservation with the Wind River Mountains in the background. Horses played an integral part of the life of the tribe. When the Arapaho first saw the Europeans and their horses, they realized how their life could change. They raided other Native American tribes, mainly the Pawnee and Comanche, to get the horses they needed.

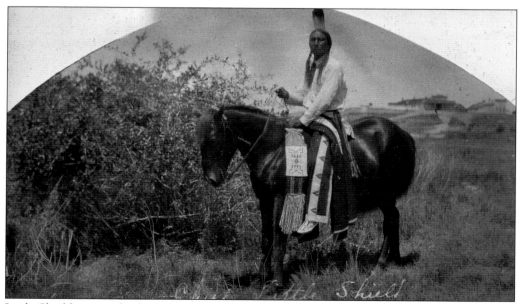

Little Shield, a war chieftain, is seen here outside of the town of Arapaho. With the separate communities located on opposite sides of the reservation, settlements, mercantile establishments, ration houses, and missions were set up for the Northern Arapaho tribe as well.

Sharp Nose, shown here in a second lieutenant cavalry uniform, was another of the Northern Arapaho chiefs who had signed the agreement with the United States moving the tribe to the reservation. Only because the warriors had worked as scouts in 1877 and 1878 were they allowed to remain in Wyoming Territory. Despite this, the Arapaho kept pressing the government for land of their own.

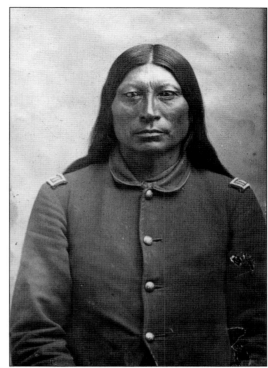

Yellow Dress is seen outside her teepee working on a hide. The women of the tribes tanned and cured the hides that the men would provide from their hunting expeditions. These hides were used to make clothing, shelter, and tools.

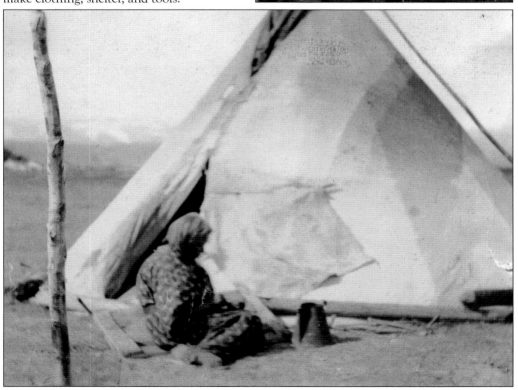

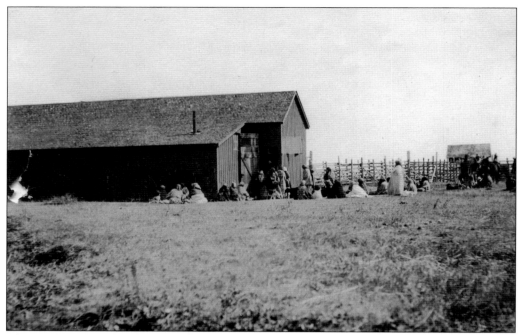

Though the tribe could move around the Fremont County area and continue to hunt, rations were provided for the Arapaho and Shoshone alike. The older members enjoyed the rations provided, especially during the long, harsh winters.

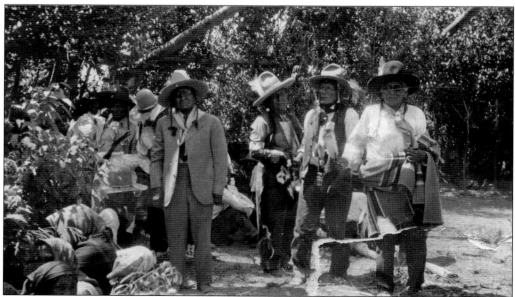

The Arapaho, like the Shoshone, continued their traditions. Dances were a large part of the culture and society of both tribes.

Four

LANDER TOWN SITE

Wyoming was being settled, and with settlement comes the need for goods to be brought in and goods to be shipped out. This all happened by freight wagons with 16- to 20-hitch mule or horse teams crossing vast areas to move the goods from the railhead to the settlements. The closest railhead to the settlements of South Pass, Lander, and Fort Washakie was Rawlins, 125 miles away. The tonnage needed for stores and Native American rations filled up three to four wagons three times per week. The wool and produce going back out could easily fill up three to four wagons. This little settlement of Lander became a freighting hub.

In 1875, the people in this small community applied for a post office. The U.S. Postal Service would not approve the name Pushroot. Benjamin Franklin Lowe suggested the name "Lander" after Frederick W. Lander, the surveyor who created the Lander cutoff. Lowe had come to know Lander during the construction of the road. In March 1875, the post office in Lander was opened with James I. Patten as the first postmaster.

Obtaining the acreage from Pres. Rutherford B. Hayes, in 1880, B. F. Lowe, P. P. Dickinson, and E. A. Amoretti established the Lander Townsite Company. The land was surveyed, and the town was laid out. Lots were now for sale, and people were ready to buy land and establish homes and businesses. Once Lander was a real town, the boom was on. The word was spread by letter to friends and relatives and in newspapers that various businesses were being established and people to work in those businesses were needed.

The Eighth Wyoming Legislative Assembly created Fremont County out of the northern portion of Sweetwater County on March 5, 1884, and it was organized on May 6, 1884. Named for the explorer John C. Fremont, the county stretched northward to the Montana border. Lander was made the county seat, and by the time Wyoming received statehood in 1890, Lander had a booming population of 525.

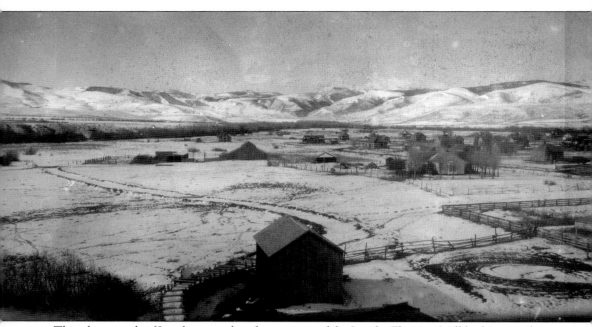

This photograph of Lander was taken from on top of the Lander Flouring Mill looking southwest. The mill water raceway is in the left foreground. A few homes, along with corrals and barns, make up the town. The Wind River Mountains make a spectacular setting.

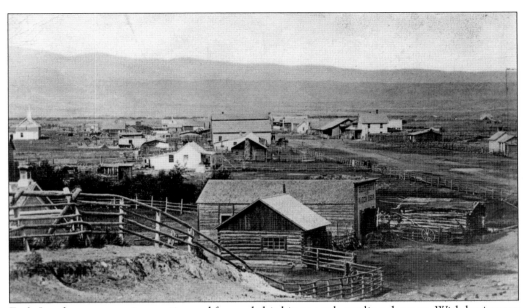

Early Lander saw many innovative and forward-thinking people settling the area. With businesses and products rivaling those back east, Lander was a very progressive, centralized area of activity. Along with the more prominent businessmen who called Lander their home, there were also many talented tradesmen whose work can still be seen in all areas of the town.

Benjamin Franklin Lowe was a freighter and established a small homestead in the Lander Valley area. It was Lowe that applied to Pres. Rutherford B. Hayes and received the patent for the land that comprises Lander. He asked his good friend Peter Dickinson to go in with him to establish the Lander Townsite Company. Together, they invited Eugene Amoretti Sr. to join them by offering him the land for his store and bank.

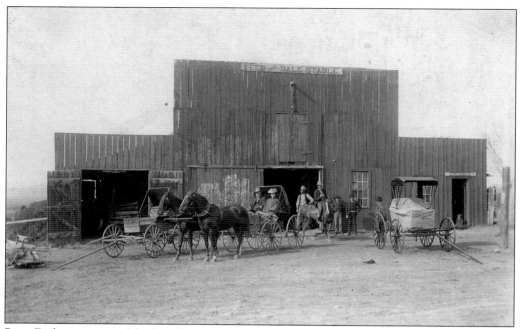

Peter Dickinson, one of the founders of the Lander town site, owned this livery and stable located on Main Street (1875). Some of the people pictured are Mr. and Mrs. Orson Grimmett in the buggy, Lee Welch standing in the door, and Dode Welch on horseback.

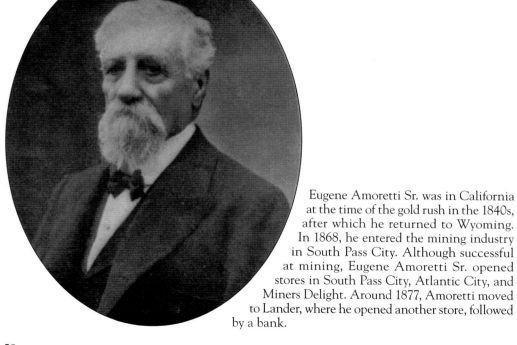

Eugene Amoretti Sr. was in California at the time of the gold rush in the 1840s, after which he returned to Wyoming. In 1868, he entered the mining industry in South Pass City. Although successful at mining, Eugene Amoretti Sr. opened stores in South Pass City, Atlantic City, and Miners Delight. Around 1877, Amoretti moved to Lander, where he opened another store, followed by a bank.

Eugene Amoretti Sr. established the First Lander Bank. The first bank was in Amoretti General Store and was brought into being as a necessity to accommodate the growing accounts for the mercantile business. A corner of the store was cleared of piles of rope, barbed wire, and other bulky merchandise and a square area blocked off to contain a safe, desk, and other simple necessities. From this simple beginning, the bank was formally organized in May 1884 as the First Lander Bank.

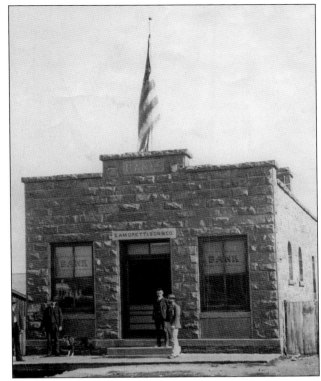

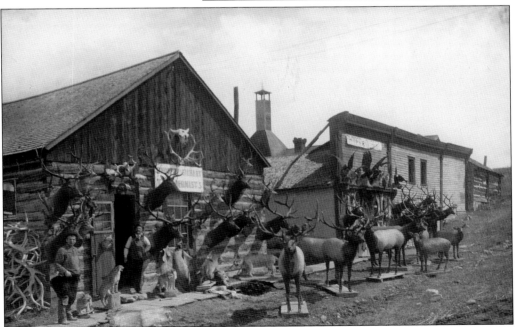

One of the earliest businesses in Lander was Rhodes and Gilbert Taxidermists. Though many hunted out of necessity to provide food for the table, the Lander area was already known in the east for big game hunting. The shop seems to be doing a booming business.

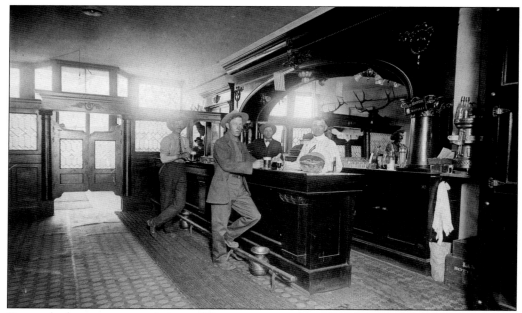

Bars and saloons were a staple in any Western town, and Lander was no different. The typical big wood and glass bar back, the bar rail, spittoons, and the swinging doors are evident at Grimmet's bar, shown here.

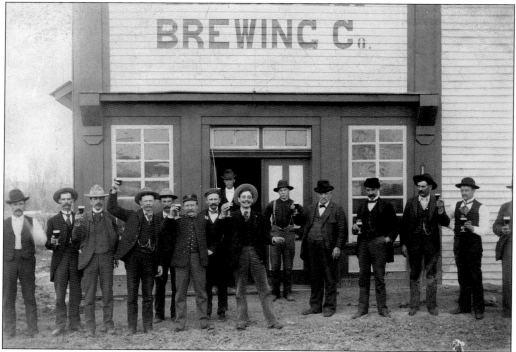

There were nine bars in the Lander City Directory of 1896. The Lander Brewing Company had a ready-made market. Started by W. N. Coalter, beer was brewed and supplied to all the bars in Lander and along the stage lines at the various roadhouses.

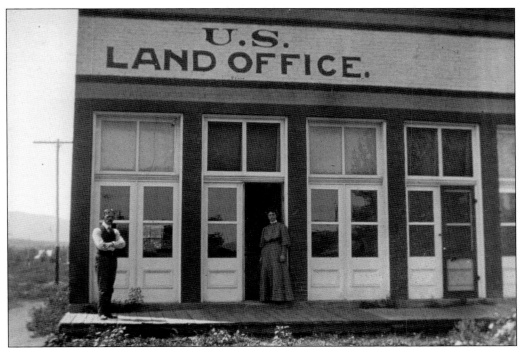

With the opening of the U.S. Land Office in Lander in 1890, would-be residents no longer had to make the three-day trip to Rawlins and file for homesteads or desert lands. Surveyor N. H. Brown had a booming business right here in Lander as every application had to include a survey.

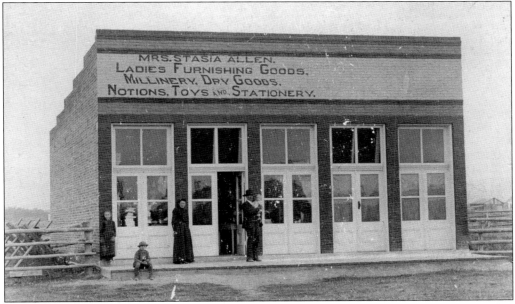

When the U. S. Land Office moved to larger quarters, Stacia Allen moved in with her ladies store. On the frontier, many women still tried to keep current with fashions, even though most of the time they were at least one year behind. Allen's establishment provided the ladies of Lander with at least some diversion.

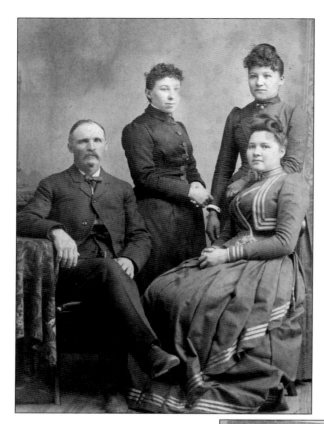

Jules Lamoreaux and his family first came to South Pass City from South Dakota in April 1868. Lamoreaux was married to Chief Gall's (Sioux) sister, Elizabeth Woman Dress. Jules is pictured with his some of his daughters—Mary, Dora, and Eugenie.

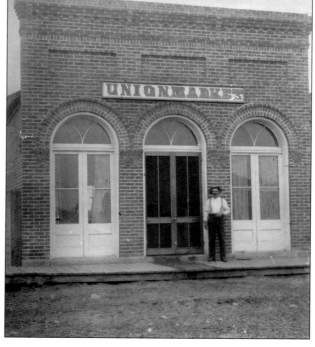

Tired of the mercantile business in Atlantic City, Jules purchased and operated a freighting outfit until 1875 when he took up a homestead in Lander. There he owned the Union Market with his son-in-law Ed Farlow (married to Elizabeth "Lizzie").

In 1866, at the age of 20, Worden P. Noble moved from New York to Fort Laramie as a bookkeeper for the firm of Jules, Ecoffey, and Cuny. In 1874, he began in the cattle business with 1,000 head, along with large investments in the sheep business with a range on the Sweetwater. In 1880, Noble was appointed trader at the Shoshone Agency. In 1885, Noble and A. D. Lane started a general store in Lander.

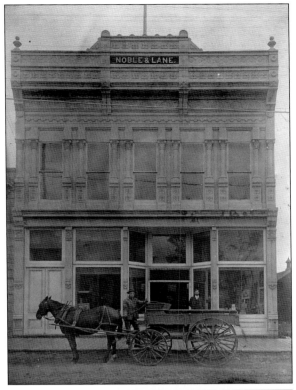

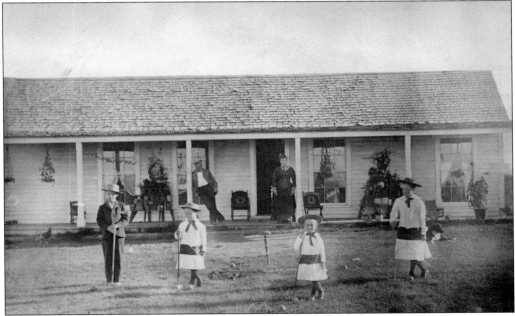

In 1893, Word Noble married Maggie Holloran. They had four children: Ida, Fred, Edith, and Mayme. As businessmen became more prosperous with the growth of Lander, their residences also reflected their newfound status, as evidenced in this photograph of the Noble home.

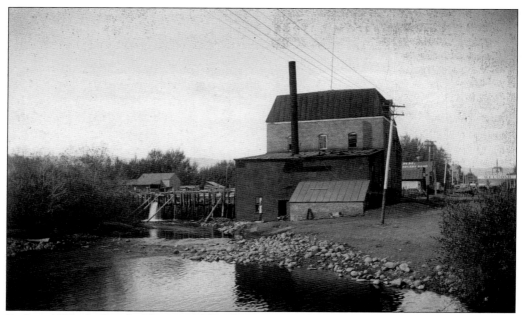

Built in 1888, the Lander Flouring Mill is four stories and was erected entirely by Lander capital at the cost of more than $20,000. It had a capacity of 60 barrels of flour per day and was supplied with both steam and waterpower. Since the steam engine had to run 24 hours a day, the mill provided electricity to Lander during its "off hours."

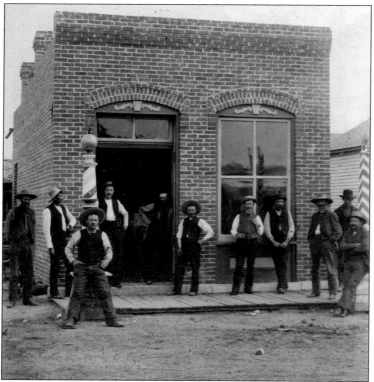

The 1894 advertisement for this brick building in the Fremont Clipper reads: "Metropolitan Barber Shop, J. W. H. Shoo, Proprietor. Facial operator, physiognomical hairdresser, cranium manipulator, and capillary abridger. Shaving and hair-cutting with ambidextrous and modernized facility at W. N. Coalter's."

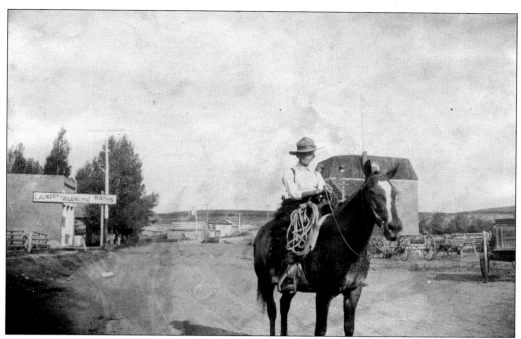

Looking east on Main Street, past the young man astride his horse, one can see the Lander Flouring Mill on the right. On the north side of the street (left) is the laundry owned by Sam Sing, and across the bridge is the old brewing company and the taxidermist. The trees are where the river runs.

Sam Sing was born in 1859 in China. As an adult, he made his way to San Francisco and then the gold fields of Wyoming. After the mines played out, he moved to Lander with quite a hefty bankroll. Sam opened up the gambling games in the best saloon in town, the Bridge Hotel and Saloon. When a drifter began playing poker with Sam, the drifter soon had most of Sam's bankroll. Sam then went to work as a cook for Eugene Amoretti Sr. After saving enough, he purchased a laundry. As the laundry business prospered, Sam also bought many lots in the new town of Lander, along with going into the cattle business with various partners and buying property outside of Lander, which produced hundreds of barrels of oil. Sam died in 1926 a very wealthy man.

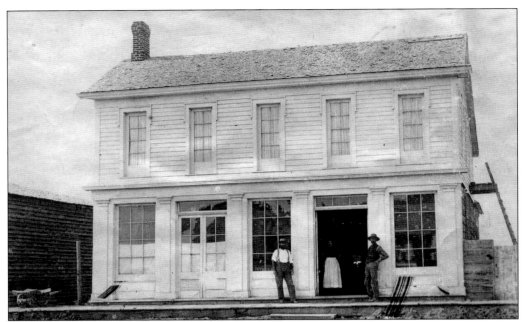

Louis Poire was born in France, but traveled to South Pass in 1865, where he opened a general store. During that time he also acquired the Caribou and Arthur gold mines, which yielded several thousands of dollars worth of gold. Poire had it minted into $5 and $10 gold pieces, which he then buried in Lander after he opened his store there in the 1870s. With the likes of Butch Cassidy and other outlaws roaming the streets of Lander, he did not trust the banks. The gold has never been found, or if it has, no one is talking.

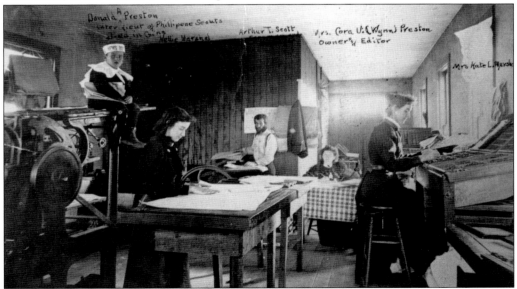

The *Wind River Mountaineer* was the oldest newspaper in Lander. Taken about 1898, the photograph shows Arthur T. Scott, foreman and manager; Cora Wynn Preston, owner and editor; Kate Merski, typesetter; and Nellie Marshall, layout. A very young Donald Preston is sitting on top of the press.

Coming west to Rawlins from Pennsylvania in 1884, Winfield Scott Firestone began his life in the west as a mechanic. The next year he married Mary Nave, and they moved to Lander, joining Hans Rasmusson in his hardware business. "Win" and Mary had seven children—Winfield Jr., Guy, Dora, John, George, Amy, and Annette. The couple remained in Lander until their deaths.

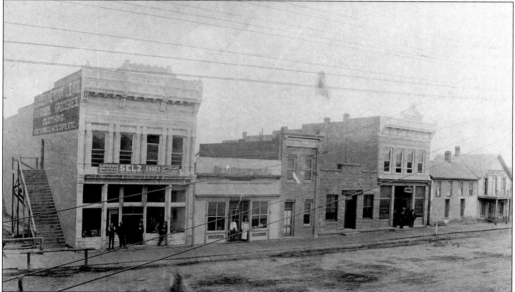

Win Firestone proved himself to Hans Rasmusson, who took him on as a partner, and by the early 1890s business was booming. In 1894, Win was elected mayor. In 1900, Rasmusson signed over the entire operation to Firestone. That same year, Win became the manager of the local electric light and power system. The Firestones were one of the most prominent families in Fremont County.

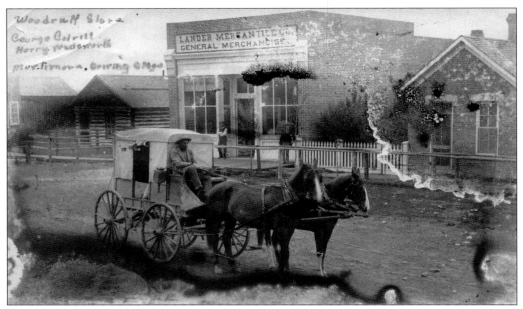

H. E. Wadsworth managed the Lander Mercantile, also known as the Woodruff Store. J. D. Woodruff was one of the first to investigate the reported gold fields at South Pass in 1867. At that time, he was employed as a hunter at Fort Laramie and accepted the invitation. Woodruff saw enough that he returned to the gold fields the next year, and he played an integral part in the development of Lander and Fremont County.

William H. Rhein arrived in Lander in 1886 and opened a tin shop on Main Street. The business flourished, and in a few years a large brick store was built. The W. H. Rhein hardware store was one of the leading business firms in town. He married Eliza Mercer and they had one son, Horace W. Rhein. After 31 years in business (1917), W. H. Rhein retired and sold the business and inventory to Arthur Vaughn and H. B. Macey.

The lifeline for the early settlers was the Rawlins-Fort Washakie Road, Rawlins being the nearest railhead for the Union Pacific. Passengers boarded the stage in Rawlins at 7:00 a.m. and proceeded on a trip covering 125 miles in approximately 24 to 30 hours of constant travel. Road ranches and stage stations were located along the route. Meals were provided (for a fee); facilities and horse teams were changed out during a 30-minute stop. In the winter, sleighs were used.

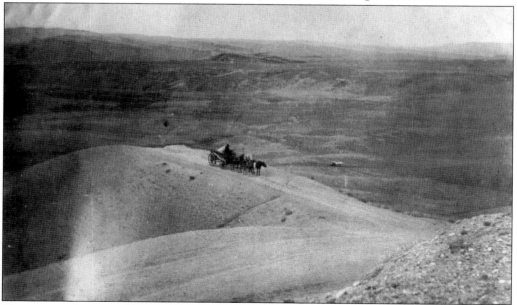

The stage road on top of Beaver Rim was a hazardous stretch of 12 miles in which many passengers elected to walk, especially after seeing the many freight wagons in a pile of lumber off the sides of the rim.

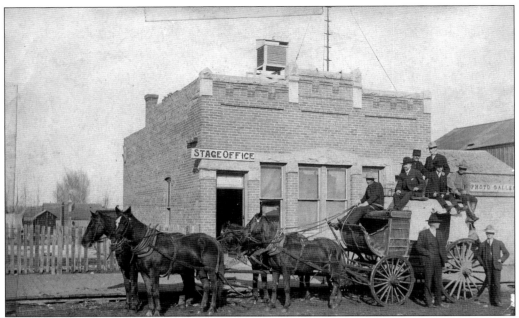

The Lander Stage Station was located at Second and Main Streets. One stage ran between Casper and Lander with stops in Moneta, Lysite, and Shoshone. It was a three-day journey, running all day and all night. The other stage came from Rawlins, up over the Continental Divide. The stations were 15 miles apart, where the horses were changed out, and passengers got a brief respite from the dust and movement. The last stage pulled into Lander in 1906 after the completion of the Chicago and Northwestern Railroad to Lander.

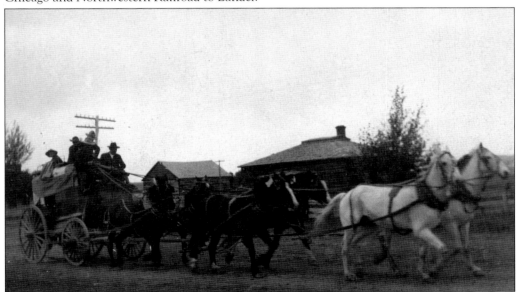

The stage in and out of Lander was an adventure not to be taken lightly by the passengers. The price of a ticket from Rawlins to Lander did not buy comfort—only transportation. Efficiency of the mail moving through on time is pictured with this six-horse hitch and some passengers riding on top of the stage. Other passengers were probably filling the inside of this coach.

Mike Murphy was an enterprising and respected man. For many years he was involved in gold mining in Colorado, Idaho, and Wyoming. His prospecting efforts met with varying success. In 1883, he and his brother Frank Murphy of Omaha, Nebraska, purchased a natural oil spring from Dr. George B. Graff.

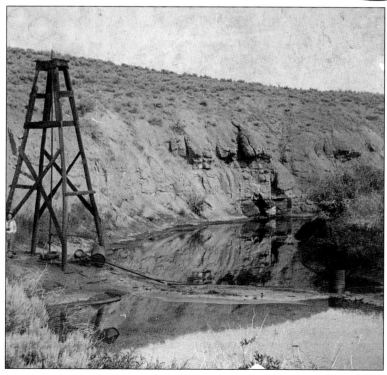

In the years following Murphy's purchase of the natural oil spring, three wells were drilled with phenomenal flows in each one. Murphy No. 1 came in on 1884. In 1903, he sold the Popo Agie Oil Field to an Englishman. Mike Murphy died in 1905.

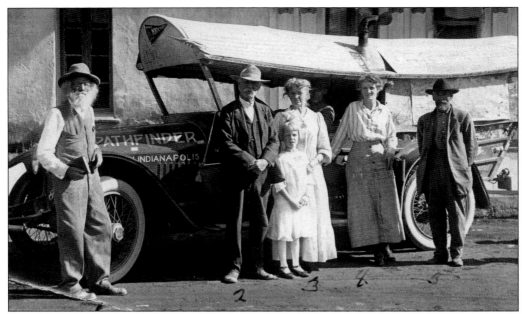

Many of the settlers referred to themselves as pioneers, as they were the first in the Lander Valley area. Three pioneers that came right after the Civil War and settled into frontier life were Ezra Meeker, H. G. Nickerson and family, and Ernest Hornecker. Living the history of the area, they came to the valley on horseback with their possessions in freighting wagons. Here they have been touring in one of the automobile camp outfits out of Indiana.

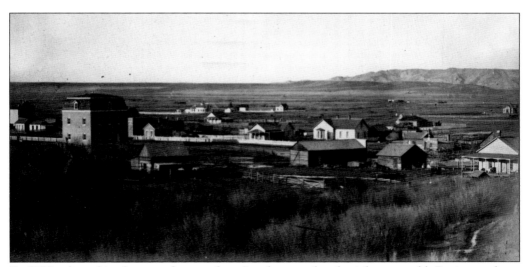

By 1888, when this photograph was taken, Lander was already eight years old. Businesses have become going concerns, and homes have been built. The large building in the front is the Lander Flouring Mill. This is the view from the Popo Agie River looking west-northwest. Notice the lack of trees.

72

Five

SOPHISTICATION

The Lander pioneers, having emigrated from a variety of backgrounds, brought with them the ideals of eastern sophistication. Lander boasted an opera house, which the locals frequented with regularity, bringing an unexpected measure of class to the Western frontier town. Along with this type of entertainment, there were also other, more regular gatherings, including various fraternal organizations and dances that were frequently held at Coalter's Opera House, and had an orchestra made up of Lander locals. The need for social organizations spanned the thousands of miles that the pioneers had traveled, as well as the more structured aspects of everyday life.

Churches of all denominations were a commonly found example of the everyday life in Lander. The original churches in the Lander area were the Catholic Church, 1883; the Protestant Episcopal Church, 1884; the Methodist (Episcopal) Church; and the Baptist Church, 1908. Along with the churches found in Lander, there were also missions located on the Wind River Indian Reservation, the largest being St. Stephens, which was built in 1884 and saw its first students in 1888.

Along with the more "civilized" aspects of society, Lander also saw another side of society in the form of athletic organizations. Almost from the beginning, there were baseball teams spanning the entire area, including some of the cavalry officers from Fort Washakie, as well as a team in Hudson, both of which the Lander team played against. After the schools were in place, Lander also had a football team and a basketball team. Another large sporting event for the citizens of Lander was the rodeo, which is a very proud accomplishment for the town, as it was the first paid rodeo in Wyoming. Lander still hosts the annual Pioneer Days Rodeo every year.

Lander had a very nice group of bands, including an all-ladies band. Some of the other early, well-known societal groups consisted of the Knights of Pythias, the Woodsmen of World, the Masons, the Odd Fellows, and the many local granges.

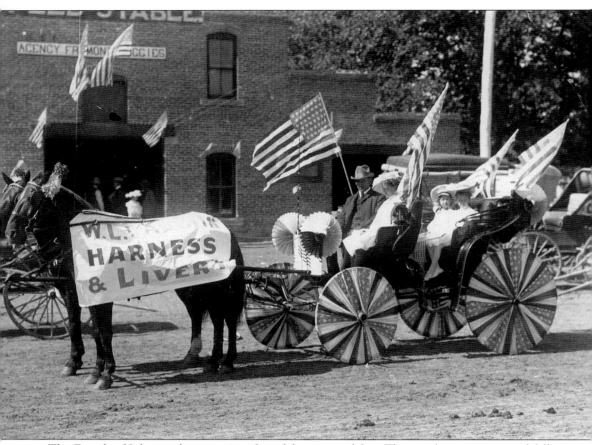

The Fourth of July parade was a time for celebration and fun. The weather was nice, and folks got to show off their new buggies and teams with decorations and maybe an advertisement for their businesses. This was quite a fancy rig, with bunting everywhere. Lander was growing, and the residents were enjoying all aspects of community life.

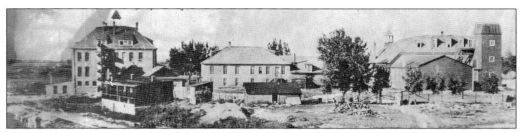

Catholic missionaries established St. Stephen's Mission for the Arapahoe Indian tribe in the late 1800s. In 1884, Fr. John J. Jutz arrived at the Arapaho camp and was joined by Brother Ursis Nunlist in the building of the mission.

The Lander area saw an influx of religious settlers who brought with them the ideals of making the unsettled West a civilized place to live. There were very few permanent ministers in the area as they traveled from town to town to perform weddings, baptisms, services, and to bring news from neighboring towns.

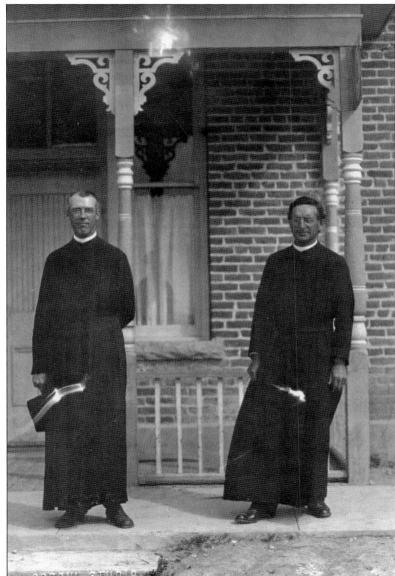

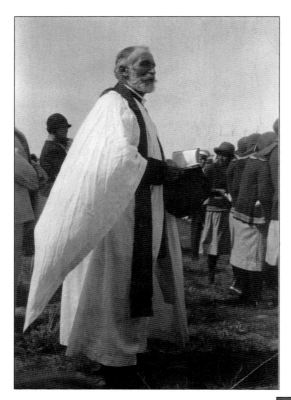

Episcopal reverend John Roberts came to the area in 1883 to minister to his chosen people, the Shoshone Indians. He was sent by the U.S. government to assist in the settlement of the Native American people to reservation life.

Laura Roberts, wife of Rev. John Roberts, was an integral part of daily life at the Shoshone mission. Laura helped teach at the mission, as well as helping in the kitchen or any other area she was needed to make the transition to life there easier. The couple had five children, and they lived in a small cabin for a couple of years prior to moving into two rooms at the mission house.

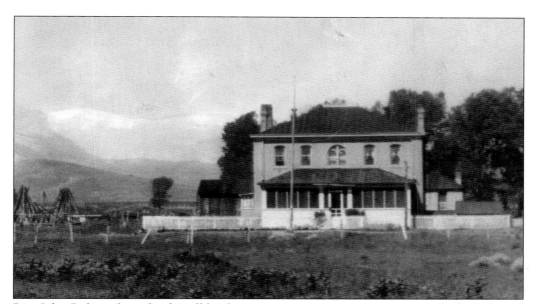

Rev. John Roberts brought this all-brick, two-story mission into existence with the help and blessings of Chief Washakie. The Roberts Mission was supported out of funds of the Episcopal Church. Later the mission moved to the new Fort Washakie School.

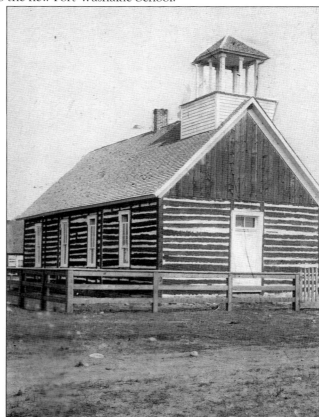

The Episcopal Church in Lander was a community-wide project. The Lander Townsite Company donated the land for the church, and Bishop Randall gifted the original $500 to the townspeople in 1884 with agreement that they build the church. Reverend Roberts continued as head counsel for the Lander church, also.

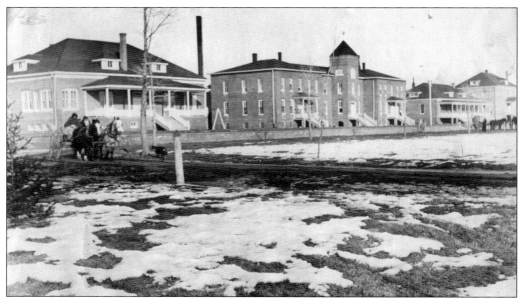

Fort Washakie School, with Reverend Roberts as superintendent, was a government boarding school for the Shoshones on the reservation, bringing them education and religion.

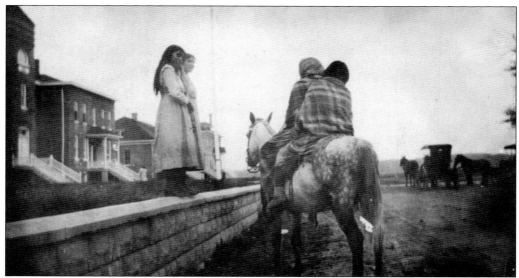

At the Fort Washakie School, as well as St. Stephens, the children were able to remain on the reservation and live in the dormitories rather than being forced to move back east for their schooling.

The Methodist church was built in 1884 with native red brick as well as native carved stone. Like other churches found in the East, this church boasted Gothic windows, vaulted ceilings, a tower, and a steeple.

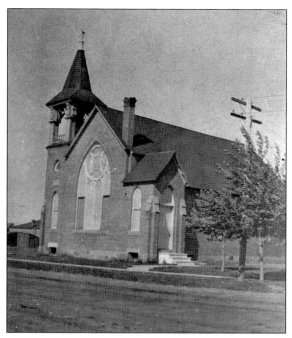

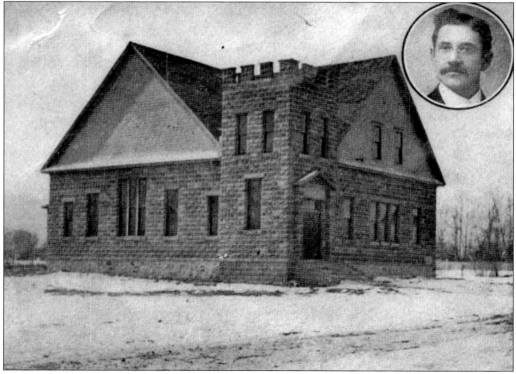

In 1908, after three years of holding services in many different places, including the Odd Fellows Hall, the Baptist church was built. The building was constructed from cement blocks and cost $5,000 to construct. Rev. Alfred Abbott was one of the early ministers.

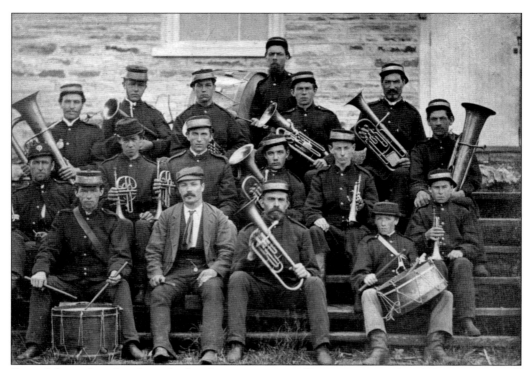

One of the earliest bands in the Lander area was actually in existence when Wyoming was still a territory. Bands were just one of the types of groups that formed in order to continue with social gatherings. The back of the photograph reads, "Lander City, Wyoming Territory, Sweet Water County."

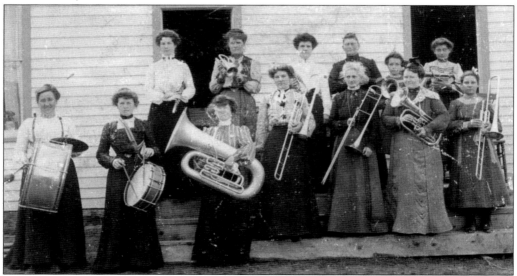

The Lander Ladies Amateur Band in the early 1900s was only one of the many different bands and groups that made their home in the Lander Valley. In following with the traditions of the east, many groups were formed to maintain a social order in the community. Along with musical groups, there were also other groups formed for those with an interest in agriculture, theater, or politics.

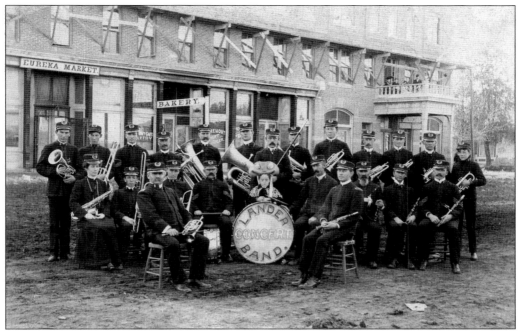

The Lander Concert Band played many different venues, including private functions, as well as town-wide events and parades. Taken about 1904, members of the band include conductor James C. Vidal, ? Horrigan, Ina Nelson Logue, Guy C. Earl, Thomas A. McCoy, Harry Corry, Lynn Hudson, William Umbanhower, W. G. Burnett, Mrs. Guy Earl, Alva Thompson, John Corry, Arthur Vaughn, Frank Miller, ? Bray, E. W. Frankenfeld, William Adams, Bert Trosper, Alva Grimmett, Albert Tweed, Frank Thomas, William Marion, and Fred Allen.

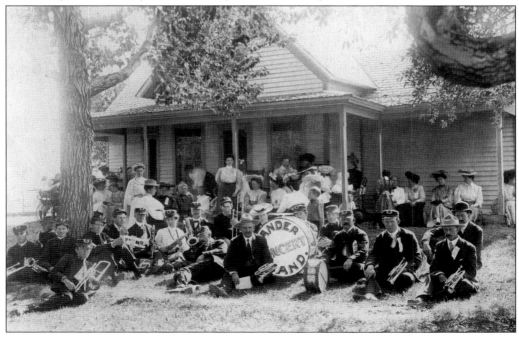

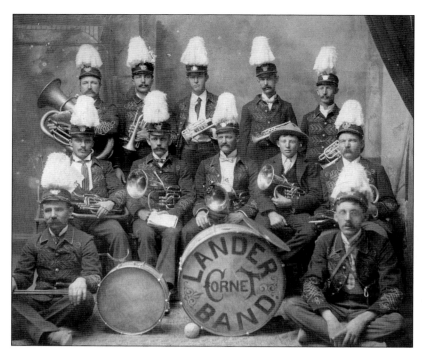

The Lander Coronet Band in 1896, dressed here in the early style, pose for a group picture. They are, from left to right, (first row) J. Warren Harrigan and Leslie Read; (second row) Bill Burnett, Bill Adams, Frank Miller, Charles Allen, and Bill Montaque; (third row) Nels Farlow, Lou Blakely, Alva Grimmett, Harry Logue, and Albert Tweed.

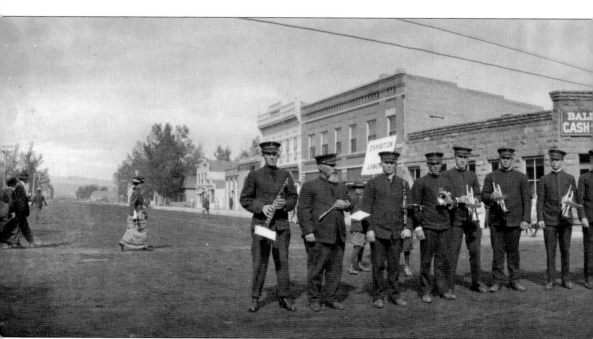

As the years progressed, so did the instruments that the musicians used. Unlike many of the other bands in the area that consisted of brass instruments and drums, these men had a variety

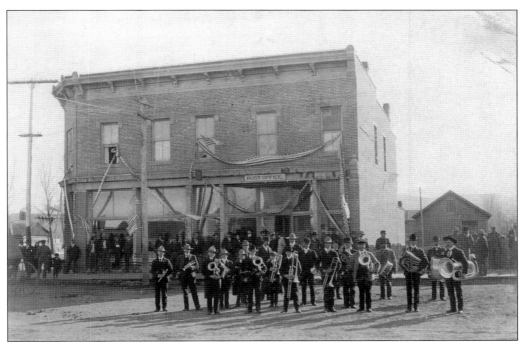

Most likely during a Fourth of July parade, this local band is playing in front of the Amoretti Building and post office on Main Street in Lander.

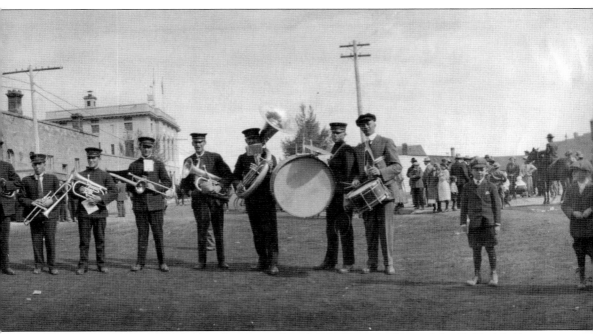

of instruments in use. Lander band is pictured on Main Street in front of the Baldwin's Store. The local bands often played for social functions and gatherings.

Woodsmen of the World group pictured above in 1897. Those identified include George Scott, William Steers, J. S. Meyers, J. H. Farthing, Edward Farthing Sr., ? Huddleston, Frank Murray, C. S. Appleby, Rev. Wright, James W. O'Neal, R. E. Blakesley, and Ed Pope.

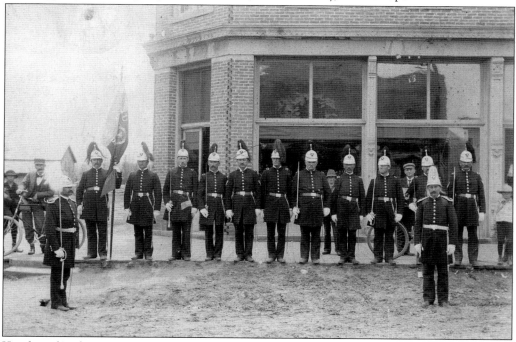

Knights of Pythias are a fraternal order dating back to 1864. Unlike many other organizations of this sort, the Pythians' sole purpose was to try to better their communities and enhance others' lives through help and friendship.

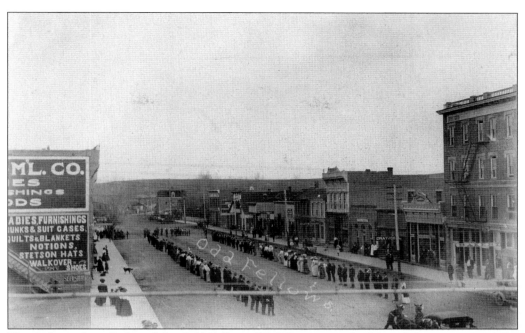

The Independent Order of the Odd Fellows (IOOF) came to the United States in 1819. The fraternal order has many followers, and new chapters opened up all over the country as the members moved to new areas. Here a ceremony is being held on Main Street.

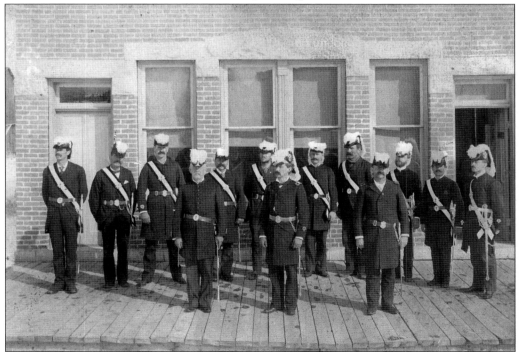

The Knights Templar members identified are Ervin Cheney, A. M. Bunce, Frank Rice, W. H. Rhein, Sam Parks, and Harry Wadsworth.

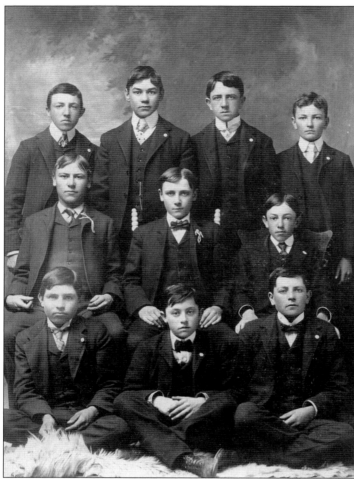

Coming Men of America, the forerunner of the DeMolay, is pictured in 1901. This club offered young men the opportunity to learn how to lead happy, successful, fulfilled lives as productive adults. They are, from left to right, (first row) Stub Farlow, Leo O'Brien, and Fred Crowley; (second row) William Marion, Harry Corey, and Thomas A. McCoy; (third row) Walter Crowley, Clarence Williams, and Bill Farlow.

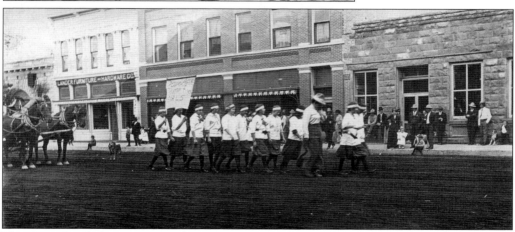

The Campfire Girls organization began in 1910 as a sister organization to the Boy Scouts. Girls were taught about camping and outdoor activities, as well as learning leadership and social skills. Here the local group is seen walking down Main Street during the parade.

Edgar H. Fourt came to Lander on a stage as many others had. As a young lawyer, he was fortunate enough to have Emile Granier, a wealthy Frenchman with mining interests in Atlantic City, as a fellow passenger. By the time they made it into Lander, Fourt had his first retainer fee. Arriving in 1890, Fourt realized that water, land, and mineral resources would be the main focus of his practice. He was appointed judge of the Ninth District in 1927.

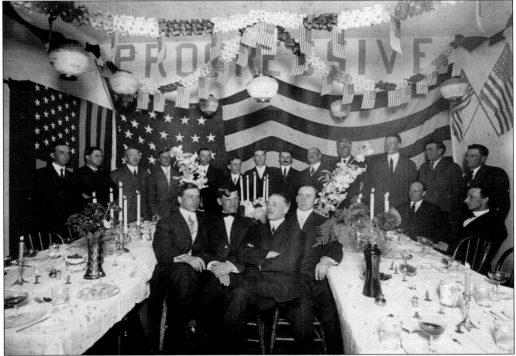

Some of the area local business professionals were members of the Progressive Club. These men were crucial to the building of this new and growing community. Among those identified are Dr. W. H. McGill, Charles Thomas, Jack Dillon, Val Maghee, H. Madden, Don Kensey, Ed Savage, Dr. W. F. Smith, Colonel Powers, Robert Landfair, Lawrence Stough, Cory Higby, Ralph Kimball, H. P. Young, Arthur Piggot, H. S. Harnsberger, Frank Stephen, Charles Orchard, and Porter Coolidge.

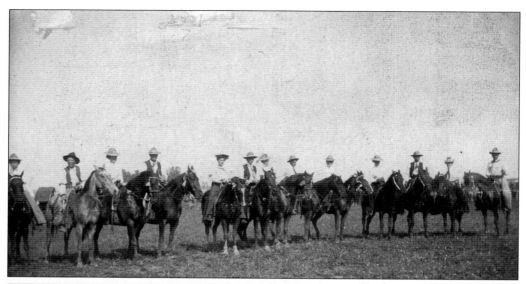

Cowboy and Cowgirl Saddle Horse Quadrille (1908) are, from left to right, Bertha Painter, Lon Welch, Mary Butler, Charles Hart, Viola Battrum, Earl Burns, Dora Lamoreaux, Leslie Reed, Ann Preston, Zelia Burns, Jules Farlow, Helen Cheney, and Cage Beebee. The Saddle Horse Quadrille participated in local fairs, rodeos, and parades.

In 1894, the first Rocky Mountain Roundup took place in Lander. This three-day event is the oldest paid rodeo in the state and is still held every year, now known as the Pioneer Days Rodeo.

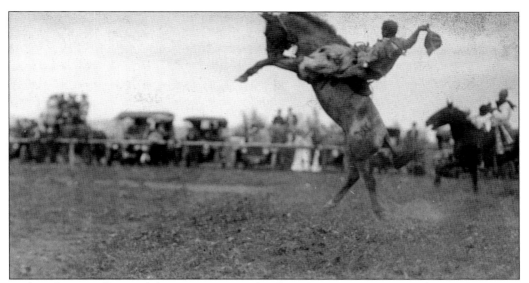

Stub Farlow is still one of the most recognized rodeo names in the area. It is believed by many that Stub was the inspiration behind the Wyoming state logo of the bucking horse and rider.

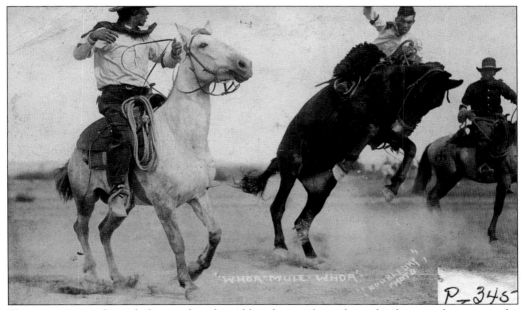

Horses were not the only livestock to be ridden during the rodeos; this large mule seems to be holding his own in the bucking competition. The riders on either side of the contestant are called pick-up men and are there to assist if the rider gets into trouble, or if he finishes his ride, the contestant will be pulled onto one of their horses for an easier dismount.

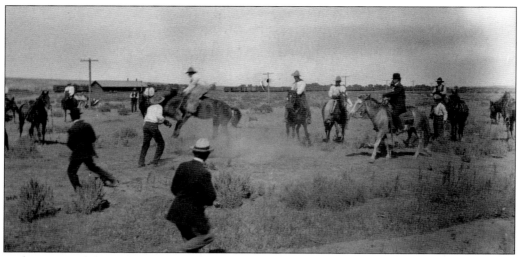

Rodeo events did not always take place at the rodeo grounds and were not always just for the cowboys. In this photograph is a glimpse of how the rodeo came into existence. With the abundance of wild horses in the area, people taking bets on who could ride the meanest one of the bunch was a fairly common occurrence. Here a diverse crowd of people is waiting for the outcome of who will win: the horse or the rider.

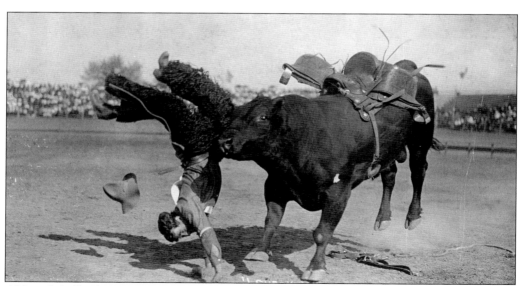

Although bull-riding was not an event in the original rodeo competitions, it became one of the main events very quickly. Unlike the bull riding of today, competitors used saddles when riding the bulls.

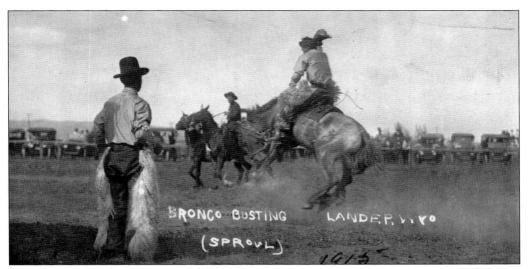

Bronc busting was the main event that brought rodeo into existence. Friendly competitions between cowboys on ranches date back to the 1700s. In the beginning, the cowboys competed to show off their skills as cowboys, and soon people were paying to watch these competitions.

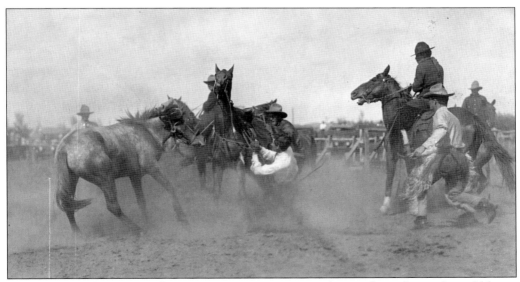

One of the wildest events that a person can compete in during the rodeo is the wild horse race. This competition is a team event consisting of three people. Two team members, called the "mugger" and the "anchor," hold on to the rope while the third member (the "rider") tries to saddle the horse. If the team can get the horse saddled, the rider must then attempt to ride the horse across the finish line. The payout for this event varies, but is basically no more than bragging rights and a small amount of cash (although most contestants do get numerous bruises and broken bones for their pay).

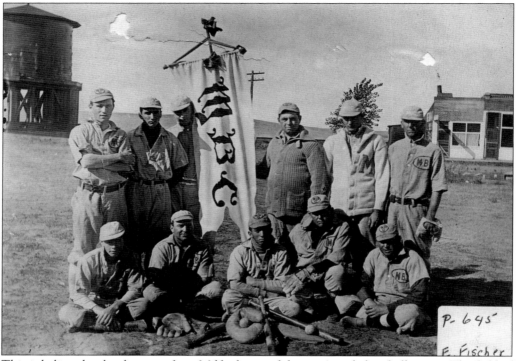

This is believed to be the team from Milford, one of the area's early baseball teams. The field of play around 1900 was much different than it is today. Games were played in any area that was large enough, even if there were boulders, sagebrush, or hills that may impede.

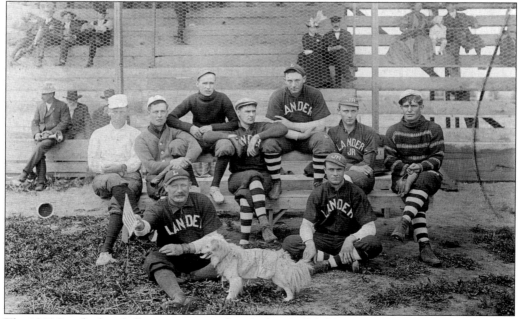

The 1909 Lander baseball team is pictured at the baseball field in town. Spectators wait through the photograph taking for the start of the game.

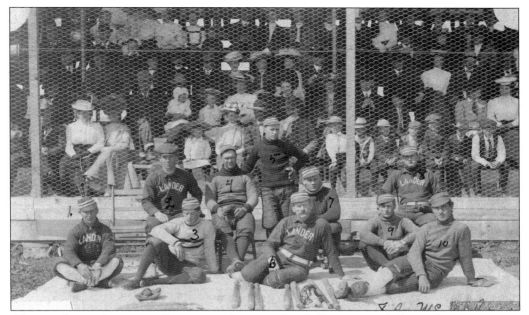

Along with a wide variety of recreational venues, baseball was an early form of entertainment for the Lander pioneers. The Lander team played against other area teams, including the cavalry team at Fort Washakie and the Hudson and Riverton teams.

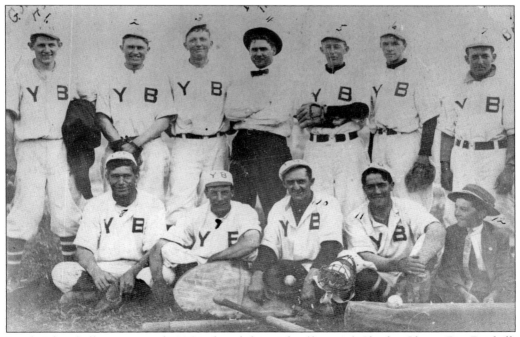

Lander's baseball team around 1906 is, from left to right, (first row) Charley Glover, Dee Driskell, C. Holbert, Ed Savage, and Francis Savage; (second row) Gov. Lester C. Hunt, Mr. Jeffries, P. Whight, Charlie E. Thomas, Fred Allen, R. F. Dunham, and Byron Smith.

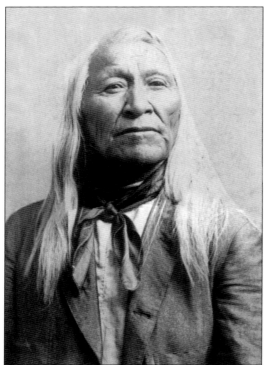

While Lander was growing and enjoying recreation and community events, Chief Washakie died. His loss in 1900 was felt by everyone. With his leadership, the Eastern Shoshone tribe was able to retain their favored hunting and fishing lands, while at the same time receiving protection from the cavalry. He was a brave warrior, and when needs arose, he protected his tribe from any enemies they faced.

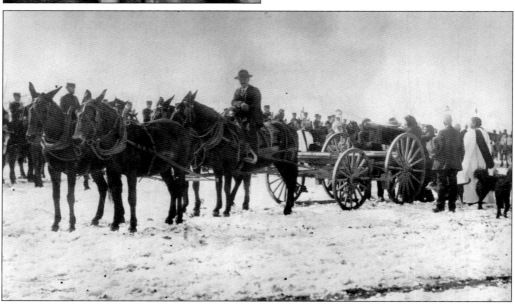

Rev. John Roberts, assisted by Rev. Sherman Coolidge, officiated at the funeral of Chief Washakie in February 1900. Chief Washakie was buried with full military honors, the first Native American ever to be accorded such recognition. Pictured is the military honor guard drawn up in the background as the casket is placed on the caisson. Reverend Roberts is in the white cassock on the left, behind the mules. Reverend Coolidge is on the right side at the back of the caisson. The driver (on mule) is Frank Allen.

Six

PROGRESS

The first Chicago and Northwestern train in Lander arrived at 11:30 a.m. on Monday, October 15, 1906. Three days of celebrations, concerts, Native American dances, and even a wagon of the Lander Valley's finest apples welcomed the newest transportation. Many townsfolk had never seen a train before that day. Although the original plans for the railroad showed that it was to be a transcontinental railroad that ended on the West Coast at either Coos Bay, Oregon, or Eureka, California, the rails went no farther than Lander, and the nickname for Lander became "Where Rails End and Trails Begin."

The arrival of the rail line meant prosperous growth for industries in Lander. Oil found at Dallas Dome could now be shipped to market, coal from Hudson could be sent east, timbers from the Wind River Mountains could be harvested and shipped, and herds of cattle and sheep could now be driven just to the rail line instead of across hundreds of miles of prairie. The rail line changed Lander not only in terms of what could be sent out, but what was brought in.

The rails brought many tourists to Yellowstone, as well as bringing modern conveniences and the latest fashions to Lander residents. George Eastman, inventor of the Eastman Kodak camera, arrived by train in 1907 to travel from Lander to Jackson on a hunting trip with some of his friends in search of the elusive bull elk. With the influx of people and products coming into Lander, new buildings started to spring up to accommodate these travelers. Along with people traveling to Yellowstone, Lander was also a destination for tourists that came in with the purpose of hunting, fishing, and exploring the local area, including Sinks Canyon.

The Federal Building, which housed the Lander Post Office, was built in 1910, and the hospital was constructed in 1912. Wyoma Flour was started in 1915 and provided the local residents with a variety of goods.

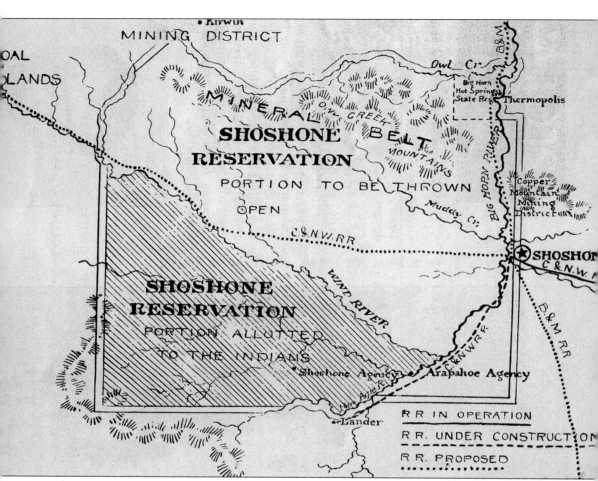

The year 1906 was the beginning of some major changes within Lander, the county, and surrounding areas. A 2,285-square-mile strip of the Shoshone Indian Reservation was opened for settlement. More land and the coming of the railroad opened the entire county up for more settlers.

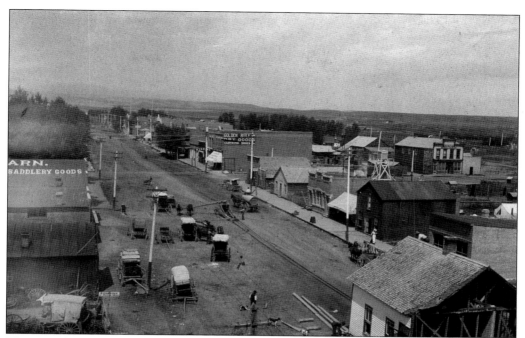

The news that the railroad was coming to Lander created lots of excitement. The businesses and houses that were in the path of the railroad had to be moved before the railroad could lay the track. Here two horses and a winch move a house up Main Street with townspeople showing little interest in the activity.

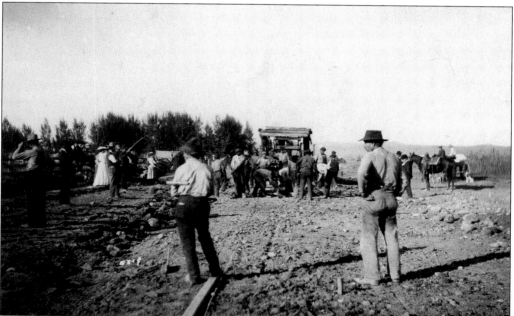

As the railroad track got closer to Lander, more and more people showed up to watch the progress. The track stopped in Lander, and Lander became known for being "Where Rails End and Trails Begin."

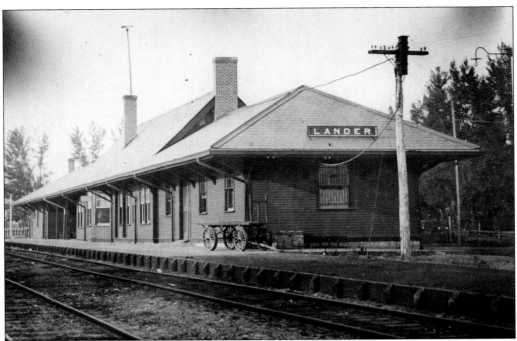

The first Chicago and Northwestern train arrived in Lander at 11:30 a.m. on Monday, October 15, 1906. After 66 years, the last train service from Lander left in November 1972.

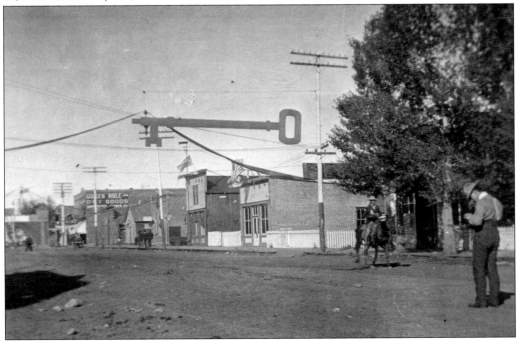

Downtown Lander spruced up for the coming of the first train. A key to the city was hung, new storefronts added, and white picket fences graced Main Street for the passengers disembarking the train.

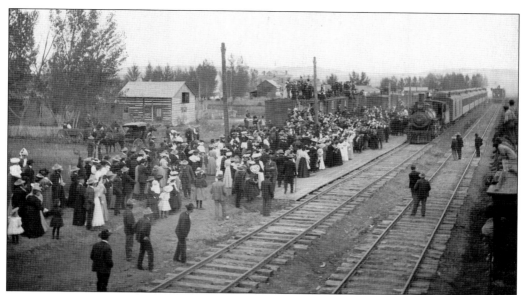

The townfolk dressed in their finest to celebrate the arrival of the first train in Lander.

The arrival of the rail line meant prosperous growth for industries in Lander. The rail line changed Lander not only in terms of what could be sent out, but what was brought in. The time factor was a major improvement—six to seven days by freight wagon to the closest railhead at Rawlins versus one day by rail.

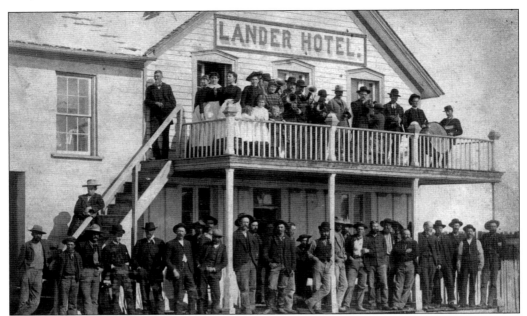

Lorenzo G. Davis celebrated his 60th birthday at the Lander Hotel on October 20, 1886. All the citizens of Lander were invited, but two or three failed to show up.

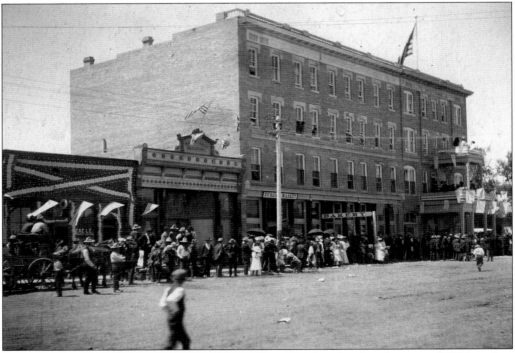

The Fremont Hotel is a fine example of the architecture found in Lander around 1900 and an example of how much accommodations for travelers had improved. Located inside the Fremont Hotel was a café, as well as a barber shop. With the travelers coming in on the railroad, on their way to Yellowstone, Lander was the last form of "civilization" found in the untamed wilderness.

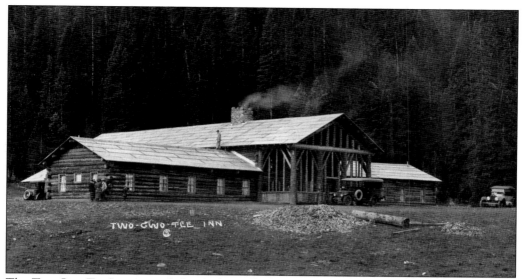

The Tow-Gwo-Tee Inn was a dude ranch overlooking Brooks Lake and was a main destination of many Easterners looking for a milder outdoor recreation. The lodge is better known as Brooks Lake Lodge. The massive log structure, with its large fireplace and dining rooms, was sure to satisfy the most scrupulous guest. Trail rides into wilderness lakes beckoned travelers to stay longer.

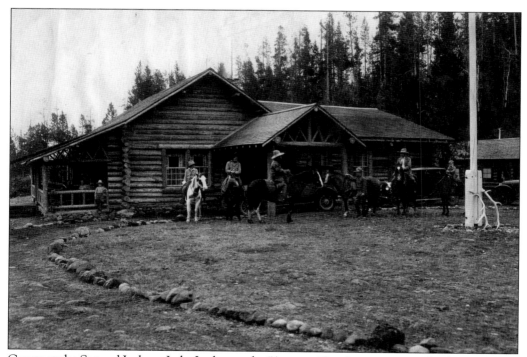

Guests at the Second Jackson Lake Lodge, or the "Amoretti Inn," are preparing for their morning trail ride. The passenger trains that came to Lander made it easier for travelers to reach these upper country lodges and helped create a strong dude ranching business.

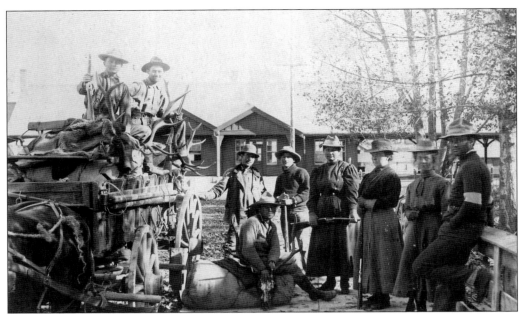

Returning home after a long and successful hunting trip in the Wind River Mountains was time to recount the success of the outing. The many elk racks and smiling faces attest to the luck of the hunt. Many fine meals will come from the bounty. The sport of the hunt and the chance to live off the land attracted many people to settle in Lander. The new railroad station appears in the background.

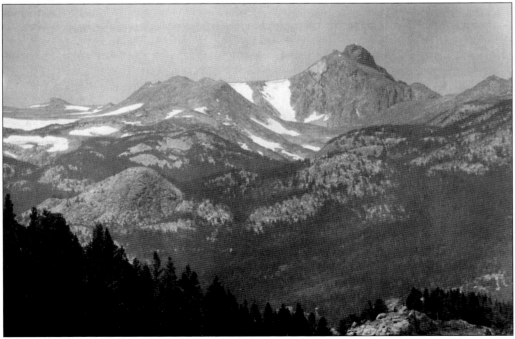

The lure to the majestic and rugged Wind River Mountains, with peaks of over 13,000 feet in elevation, is as strong today as it was when the mountain men first discovered them.

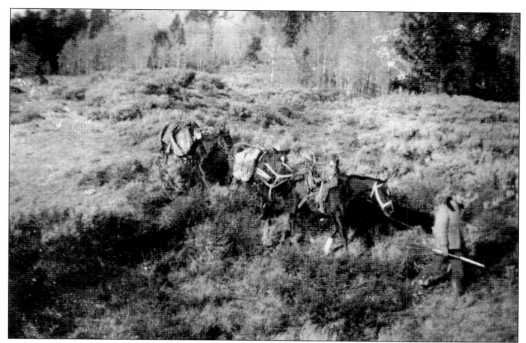

Visitors to the mountains found that horses were the fastest and easiest way to take people and their provisions to the backcountry. Here is how a successful elk hunter took to the mountains and retrieved his game.

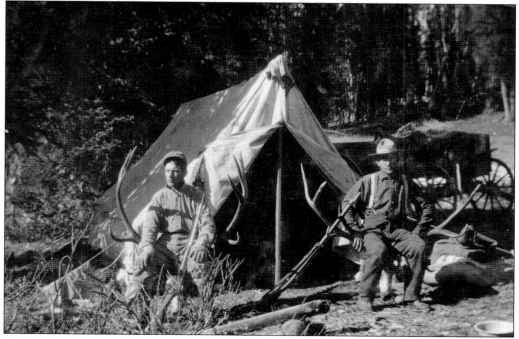

These very successful early-day hunters brought a wagon to carry their gear and most likely used their horses to hunt from this base camp.

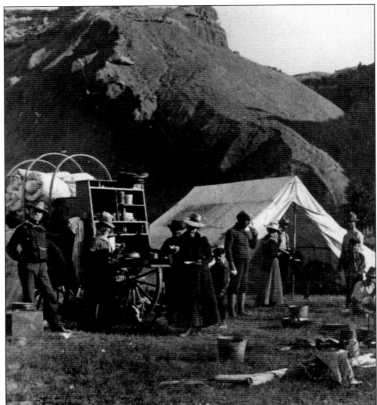

The cook in this early-day camp must be the man tired out and sitting down, as the campers seem to be gathering their food off the chuck wagon. The foothills around the Lander Valley offer a wide variety of outdoor adventures.

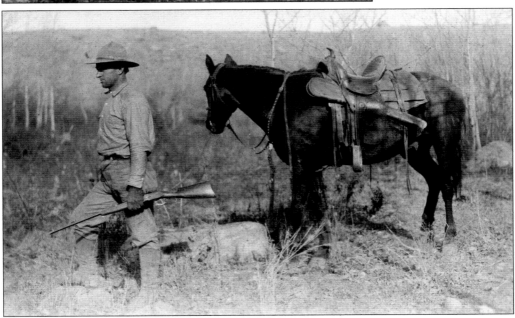

Hunting seemed to be a full-time occupation with abundant game in the Lander Valley area. The wear on the saddle bears witness to the constant carrying of his rifle.

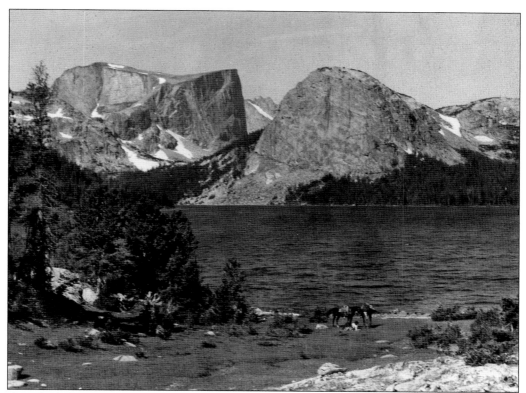

A rushed three-day pack trip could put a person at Graves Lake for some of the best fishing among the spectacular peaks that are the backbone of the Wind River Mountains. This picture show what it looked like in the early part of the 1900s. The tree line is just a stone's throw away, up the hill.

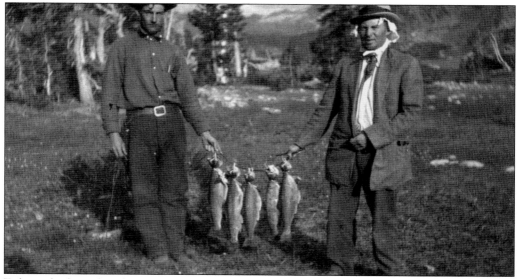

Fishing for large brook trout like these was no problem in the early days in the Lander area; mosquitoes seem to be keeping these gentlemen from smiling.

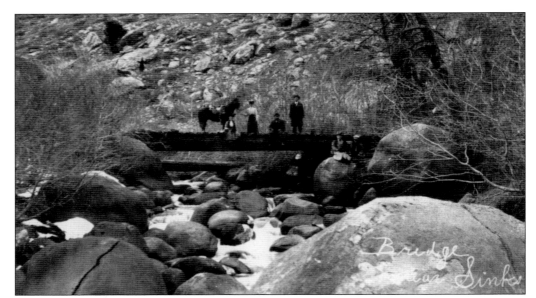

Lander was located in a great place, as a few minutes' ride on horse would put one into Sinks Canyon and an hour's ride got one up the canyon to this bridge across the Popo Agie River.

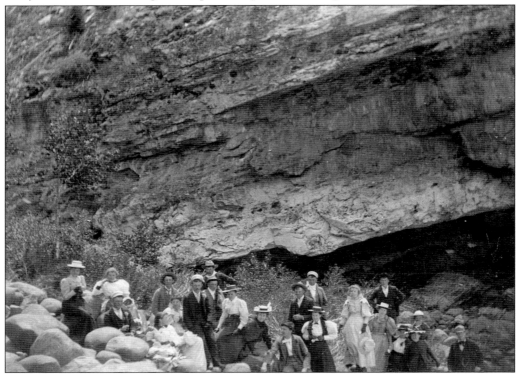

The wonderful weather of the summer days lured social groups and family gatherings to the mountains—especially to the curious Sinks Canyon, where the Popo Agie River disappears underground and rises .25 miles down the canyon in a large, sandy pool. These 22 hardy residents of Lander appeared in their finest dress for this picture at the fall of the sinks.

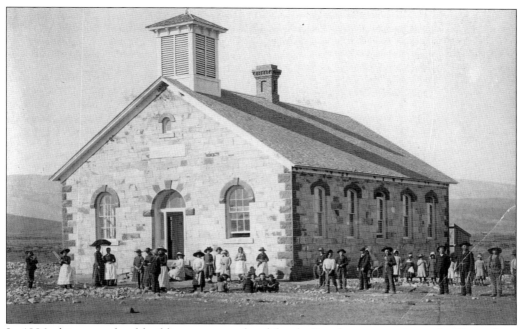

In 1886, this new school building was completed for the Lander community and still stands at Sixth and Garfield Streets.

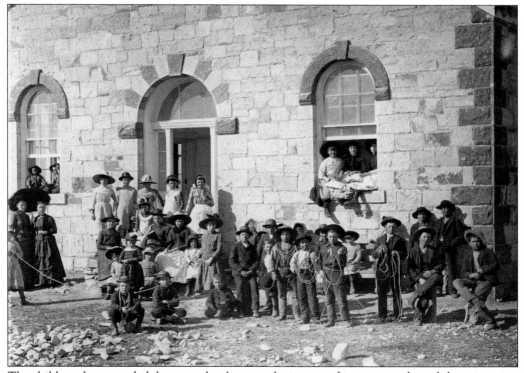

The children that attended the new school seem to be interested in ropes, as the girls have jumping ropes and the boys have roping ropes.

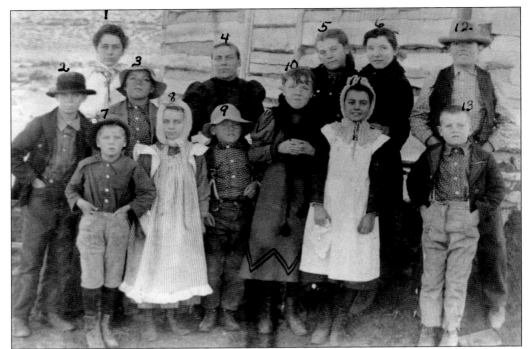

All the students of School District No. 4, upper North Fork School of 1900, turned out for this photograph. From left to right are (first row) Arthur Coon, Ethel Hiatt, George Meredith, Alzina Meredith, Laura Coon, and Roy Anderson; (second row) Charles Hiatt, John Meredith, Rebecca Hiatt, Lizzie Shockley, Bessie Leseberg, and Frank Meredith; (third row) Claire Hall, teacher.

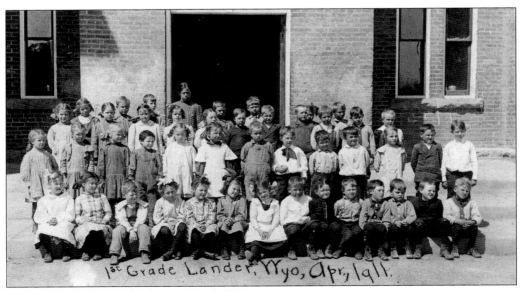

Pictured is the first grade class in April 1911.

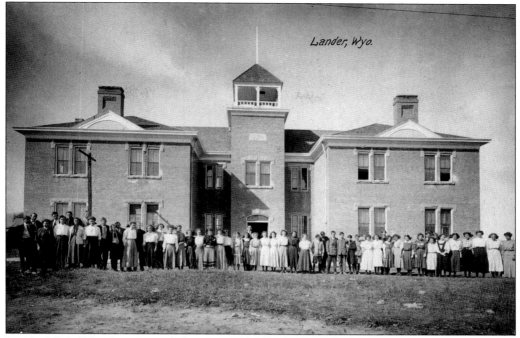

Lander High School is pictured above in 1910. The big brick building, constructed in 1895, was first used as the school for all grades.

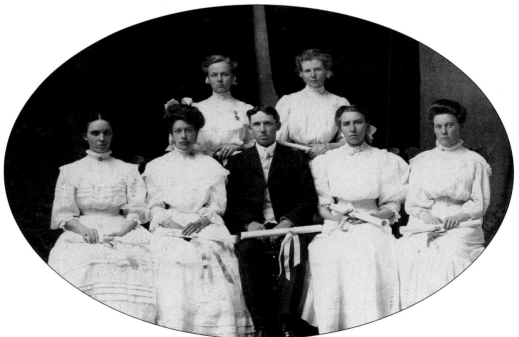

Lander High School graduates of 1906 were, from left to right, (first row) Olivia Burch, Edna Hornecker, Bob Burch, Essa Fosher, and Retta Iiams; (second row) Nellie Cameron and Mayme Savage.

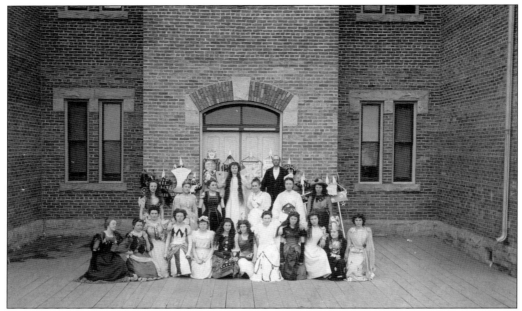

The Lander Grade School building was the location for a pageant cast photograph of the production.

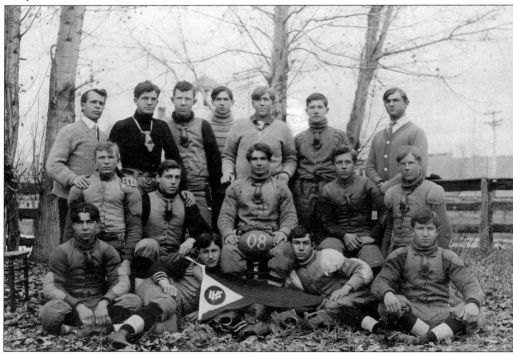

The 1908 Lander football team consisted of the following: Professor Hoadley, Rex Fanning, Lawrence Stough, Hal Burch, Ben Cochrane, Ed Savage, Coach Don Miller, Earl Honrath, Will Finch, Harry Barnum, Chase Hoadley, Ralph Cochrane, Arthur Warnock, Lew Scott, Keith Rodgers, and Eddie Hudson.

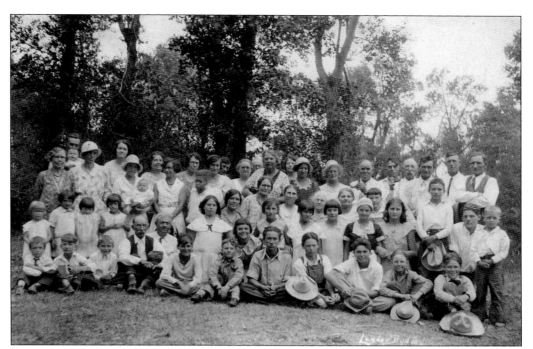

The Borners Garden Club gathered for a picture during their annual picnic. The area was homesteaded in the 1870s by John Borner, who raised beautiful grounds and gardens. This social club held meetings in which they developed their domestic skills.

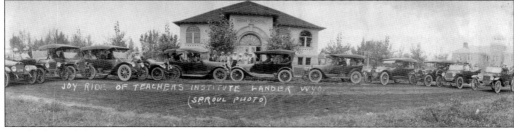

Lander hosted the Teacher's Institute in 1915. Here they participate in a joyride through town and end up at the high school. Later they all headed to Yellowstone National Park for a camping trip.

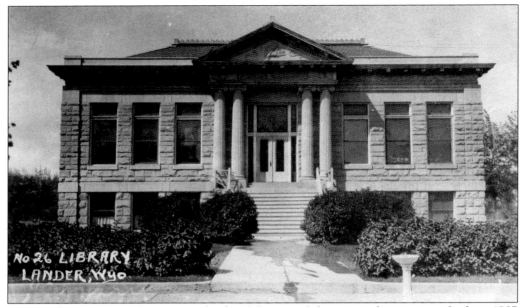

The Lander Carnegie Library, one of only 16 Carnegie Libraries in the state, was built in 1907 on land donated by Eugene Amoretti Sr.

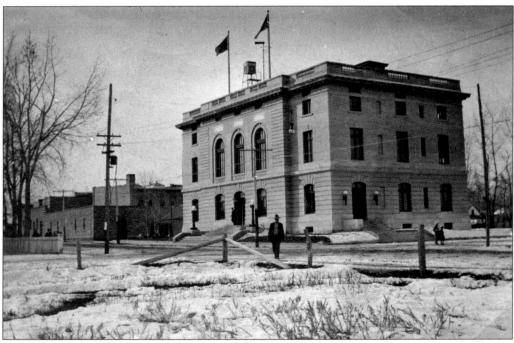

The new Federal Building of Lander contained courtrooms, the post office, the U.S. Land Office, and the U.S. Weather Bureau.

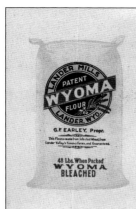

LANDER MILLS

G. F. EARLEY, Proprietor

FLOUR, BRAN, SHORTS AND FEED

PHONE 18 W

LANDER, WYOMING

G. F. Early's Lander Mills could produce 60 barrels of flour a day by water or steam power when first operated. A large electric motor was an upgrade to the mill's operation and created the need for electric power. The owner created power for the mill, and extra power went to powering the town. The Wyoma flour became a well-known brand.

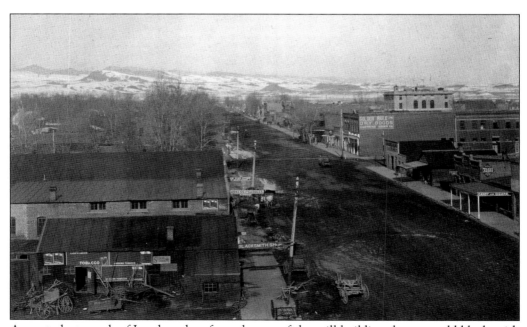

A great photograph of Lander taken from the top of the mill building shows an old blacksmith shop and the mature development of a fine community.

The Bishop Randall Hospital was built in 1912 at the top of the hill on South Second Street. The hospital was run and funded for many years by the county.

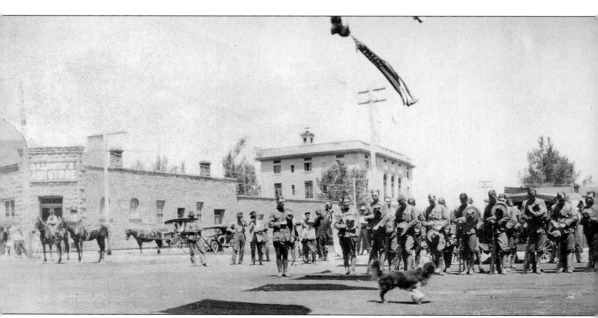

Company B assembled on Third and Main Streets before they shipped off to their various World

Dr. Francis Smith was instrumental in establishing the Bishop Randall Hospital. As the first surgeon in Fremont County, he continued his practice until his death in 1955.

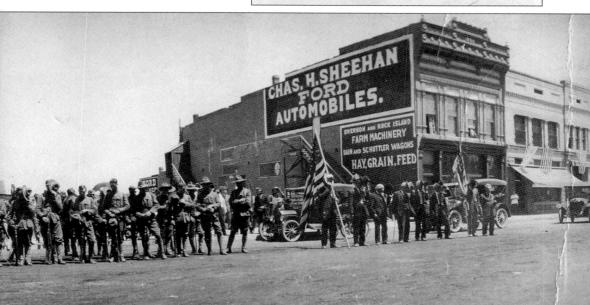

War I assignments.

World War I soldiers Lon Baldwin and L. V. Abbott, of Company B Wyoming, are pictured here.

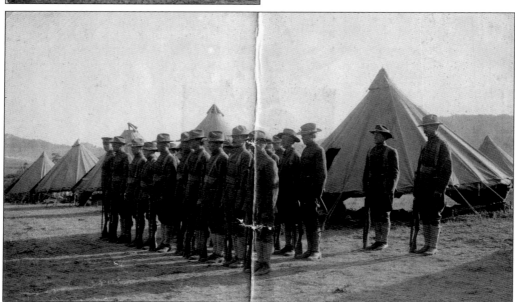

Many men were drafted from the Fremont County area during World War I. Pictured here are some local boys who were getting ready to leave their homes to fight in France. Although many of these men may have been eager to fight for their country, the loss of men took its toll on the everyday life of the Lander pioneers.

Seven

MOVING TOWARD
THE FUTURE

Located at the foot of the Wind River Mountains, Lander serves as a departure point for camping, hunting, fishing, wilderness travel, climbing, and mountaineering. Several recorded ascents of southern Wind River peaks date to the late 1800s, and undoubtedly, Native Americans who lived in the area climbed several of the peaks much earlier. Since the 1920s, alpinists have been launching trips into the Winds' Cirque of the Towers, just 20 miles west of Lander. Because of Edgar Fourt's exploration and discovery of a glacier, an interest was created in the glaciers.

Centrally located in the state, Lander competed for state capital in 1886 and bid on the Land Grant Institution, the University of Wyoming. Not winning the bid for either of these important government institutions, instead the city was awarded the State Training School in 1912.

Civilian Conservation Corps (CCC) was active in Wyoming. The Lander camp was at Sinks Canyon where the Forest Service work area was later located. The Lander camp built part of the Loop Road that connects Lander to the highway by South Pass. The brickwork in the drainage areas and the buildings are evidence of the craftsmanship during that time period. The CCC members out of Fort Washakie built the Dickinson Park Road. Once a horse trail, it became a true road bringing more people into the upper Wind River Mountains. Once in Dickinson Park, trails can take a traveler all across the Winds.

In the early 1920s, pioneer Ed Farlow was asked by film star and Wyoming resident Tim McCoy to recruit Native Americans from the Wind River Reservation to star in his upcoming motion picture *The Covered Wagon*. In the tradition of the Wild West Show of Buffalo Bill Cody, Ed Farlow and his son Jules recruited mostly Arapaho Indians and some Shoshone. Once the filming was completed, the time arrived to promote the film. The Native Americans set sail across the "big pond" to London for the opening, after stopping in New York City.

People from Lander went out and saw the world, and the world was welcomed to Lander.

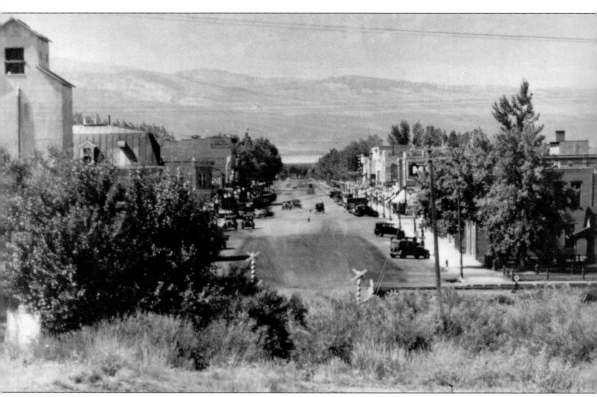

Trees, buildings, and automobiles depict how Lander has grown and prospered. No longer the dusty little town with freight teams, wagons, and saddle horses in the streets, instead a railroad crossing and telephone poles indicate progress.

Lander was becoming a modern town with a country club and a nine-hole golf course. Advertised that "spacious raised greens, and a sufficient number of traps, and natural hazards will satisfy the most ardent golfer," the country club included lockers, showers, social rooms, and dining room facilities.

In 1909, Governor Brooks of Wyoming, along with the majority of the members of the State Board of Charities and Reform, selected a 100.6-acre tract northeast of Lander "to be used as the site for the school for feeble minded and epileptics." The large brick structure was the administration building while cottages were used to house the residents.

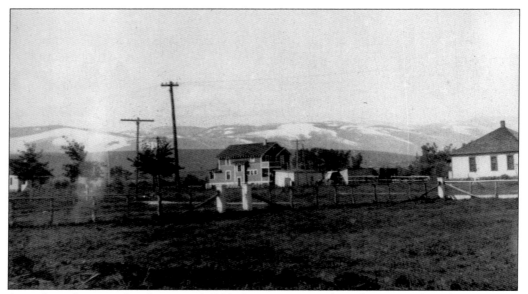

A residential area in Lander around 1920 shows some very large homes, each with a beautiful view of the Wind River Mountains. Lander was attracting many professional people, and the community was growing. The residents were very social and enjoyed outings in the mountains, games of golf, and trips on the train to Casper and points east.

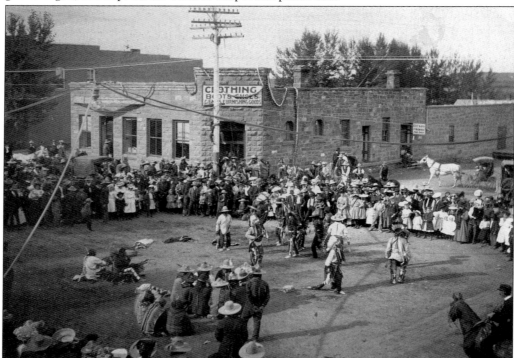

During the Fourth of July celebrations, there would be a big parade and street events, including Native American dances with participants from the reservation. These gatherings would draw a huge crowd, as seen here in front of Baldwin's.

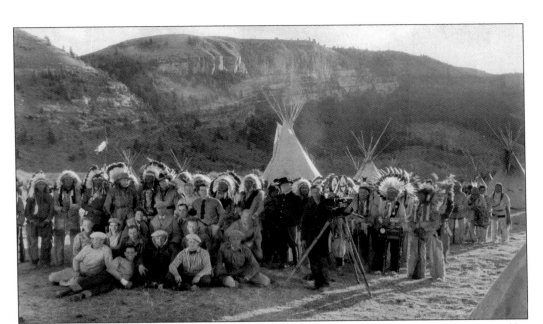

When film star and Wyoming resident Tim McCoy began preparations for his upcoming film *The Covered Wagon*, he contacted his old friend Ed Farlow to help him scout locations for the film and to provide the Native Americans necessary. Since Ed was an honorary member of the Arapaho tribe, he called on his friends there.

To help promote *The Covered Wagon*, Ed Farlow, his son Jules, and the many Native Americans cast in the film, with their families, went to London for the opening. Their layover in New York caused quite a stir when the teepees went up in New York City—for both Native Americans and New Yorkers. Most of the Arapahos had never been out of the Rocky Mountain region.

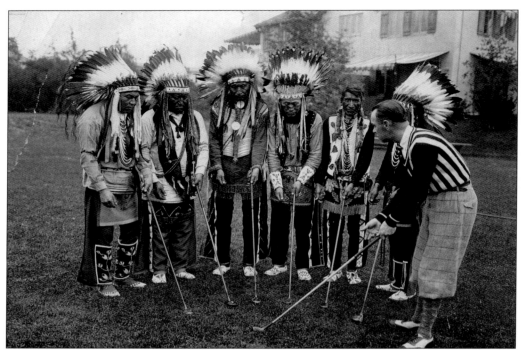

Seeing new sights and learning new things from other cultures became part of the Native Americans' education. Here Charlie Washakie, Jim Lone Bear, Goes-In-Lodge, Jack Shavehead, Bob Washington, and two unidentified men take a golf lesson.

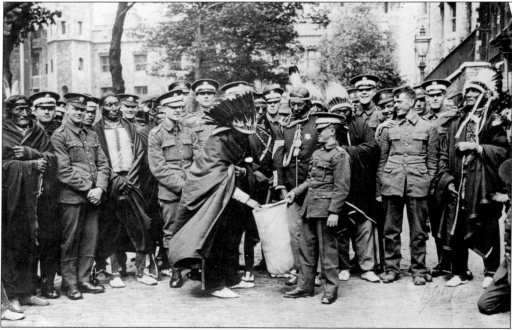

The Native Americans were toured all around London. Meeting up with a group of British soldiers, they pose for a group picture.

Not only did Lander and reservation citizens go out into the world, the world was learning more and more about the Wind River Mountains and a little town called Lander in their foothills. Tourists had been coming to Lander since the 1880s. Now dude ranches were established to provide a more "authentic" view into Western life.

What is more intriguing than a trip on a good horse far away up in the mountains to the top of the world along the Continental Divide? Clear blue skies, fragrant pines, and a day in the saddle was what many tourists were looking for and found.

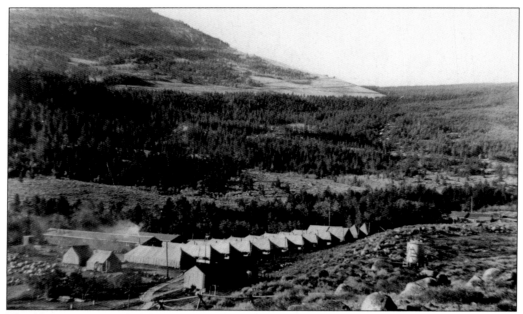

Though times were good and Lander was growing and progressing, neither the town nor the state could avoid the Depression. Two Civilian Conservation Corps (CCC) camps were established near Lander. The one pictured here was in Sinks Canyon, and the second one was above Fort Washakie.

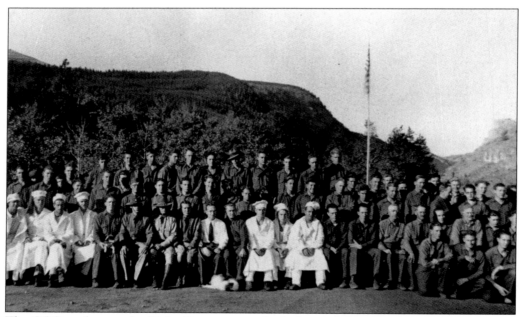

The CCC workers at the Sinks Canyon camp built the road from Bruce's camp to Worthen Meadows—thus opening up the area for camping, riding, hiking, and exploring.

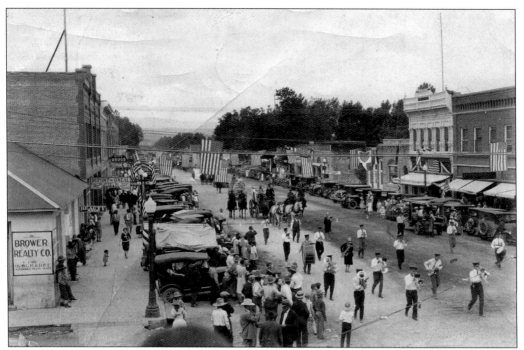

Everyone comes to town for Fourth of July, even the Shoshone and Arapaho from the reservation. They come for the parade, the rodeo, and to catch up with friends. The town is decorated; there are street vendors with treats, horseshoes, picnics, and political speakers in City Park—something for everyone.

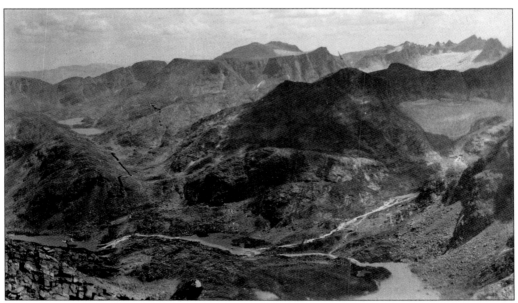

Overlooking all the growth, all the hardships, and all the joys of mankind are the majestic Wind River Mountains—always beckoning with new trails, better hunts, and places to just get lost in, away from civilization.

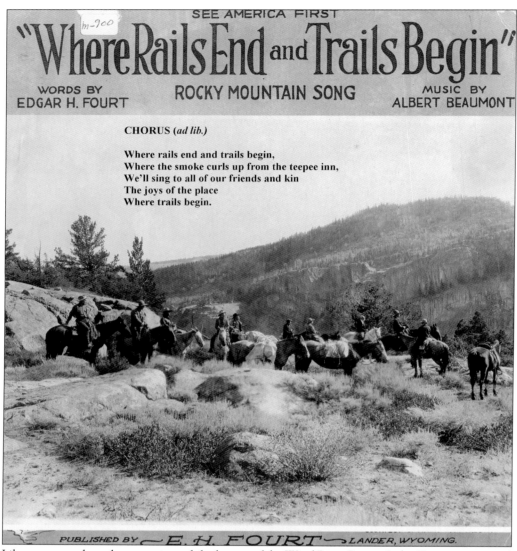

Like so many others that experienced the beauty of the Wind River Range, Judge Fourt was inspired to create and wrote "Where Rails End and Trails Begin" as the melody of the mountains.

BIBLIOGRAPHY

Clay, John. My *Life on the Range*. Chicago: Privately Printed, 1924.

Coutant, C. G. *The History of Wyoming*. Laramie: Chaplin, Spafford, and Mathison, 1899.

Dobler, Lavinia, and Loren Jost. *Rendezvous on the Wind*. Riverton: Big Bend Press, 1990.

Henderson, Kenneth A. "Wind River Range of Wyoming." *Appalachia, Vol. XIX, No 2*. Boston: The Appalachian Mountain Club, 1932.

Homsher, Lola M. *South Pass, 1868: Jim Chisholm's Journal of the Wyoming Gold Rush*. Lincoln: University of Nebraska Press, 1975.

Leckie, William H. *The Buffalo Soldiers*. Norman: University of Oklahoma Press, 1967.

Larson, T. A. *Wyoming: A History*. New York: W. W. Norton and Company, Inc., 1977.

Linford, Velma. *Wyoming Frontier State*. Denver: Old West Publishing Company, 1947.

A. W. Bowen and Company. *Progressive Men of the State of Wyoming*. Chicago, 1903.

Rickey, Don Jr. *Forty Miles a Day on Beans, and Hay*. Norman: University of Oklahoma Press, 1963.

Rosenberg, Robert G. *Historic Overview of Ranching to 1890 in Fremont County, Wyoming*. Cheyenne: Rosenberg Historical Consultants, 1989.

Smith, Frank S., and Ed R. Wynn. *The Shoshone Pathfinder*. Lander: Wind River Mountaineer, 1906.

Wight, Jermy Benton. *Frederick W. Lander and the Lander Trail*. Bedford: Star Valley Llama, 1993.

Wishart, David J. *The Fur Trade of the American West*. Lincoln: University of Nebraska Press, 1978.

Wyoming State Board of Horticulture. *The State Experimental Fruit Farm*. Laramie: The Laramie Printing Company, 1924.

www.arcadiapublishing.com

Discover books about the town where you grew up, the cities where your friends and families live, the town where your parents met, or even that retirement spot you've been dreaming about. Our Web site provides history lovers with exclusive deals, advanced notification about new titles, e-mail alerts of author events, and much more.

Find Your Place in History.